T0041681

Harry Potter™

FILM VAULT

VOLUME 7

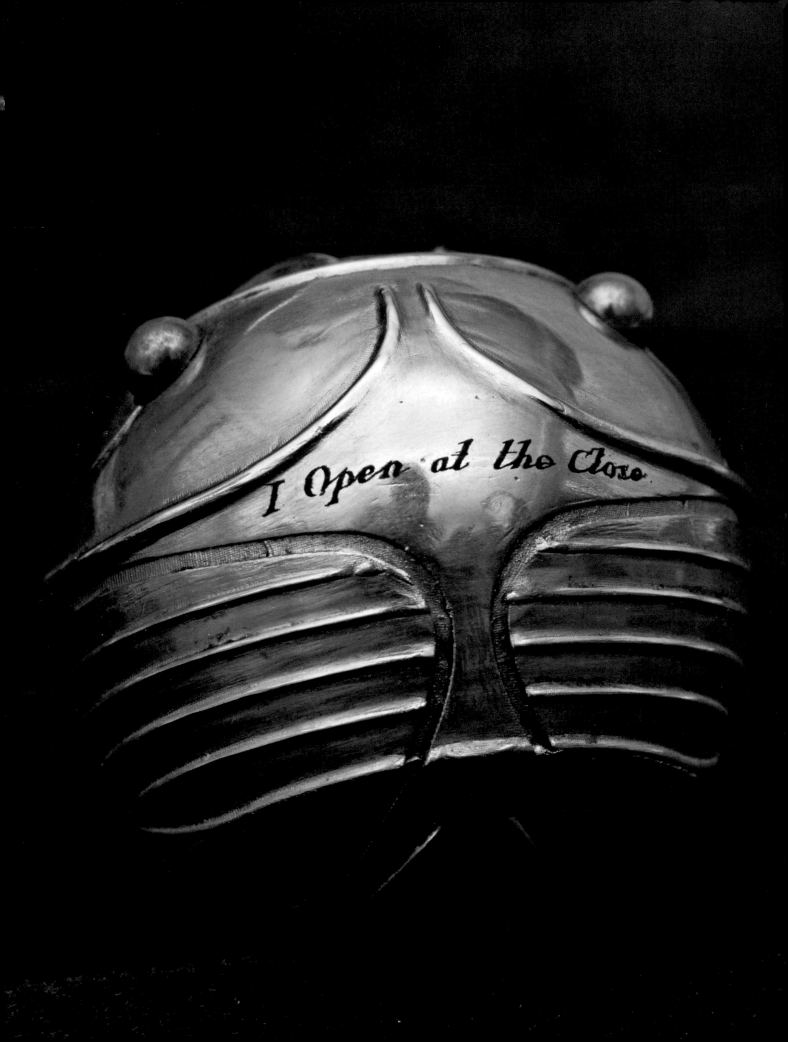

FILM VAULT

VOLUME 7

Quidditch and the Triwizard Tournament

By Jody Revenson

WIZARDING WORLD

INSIGHT EDITIONS

SAN RAFAEL · LOS ANGELES · LONDON

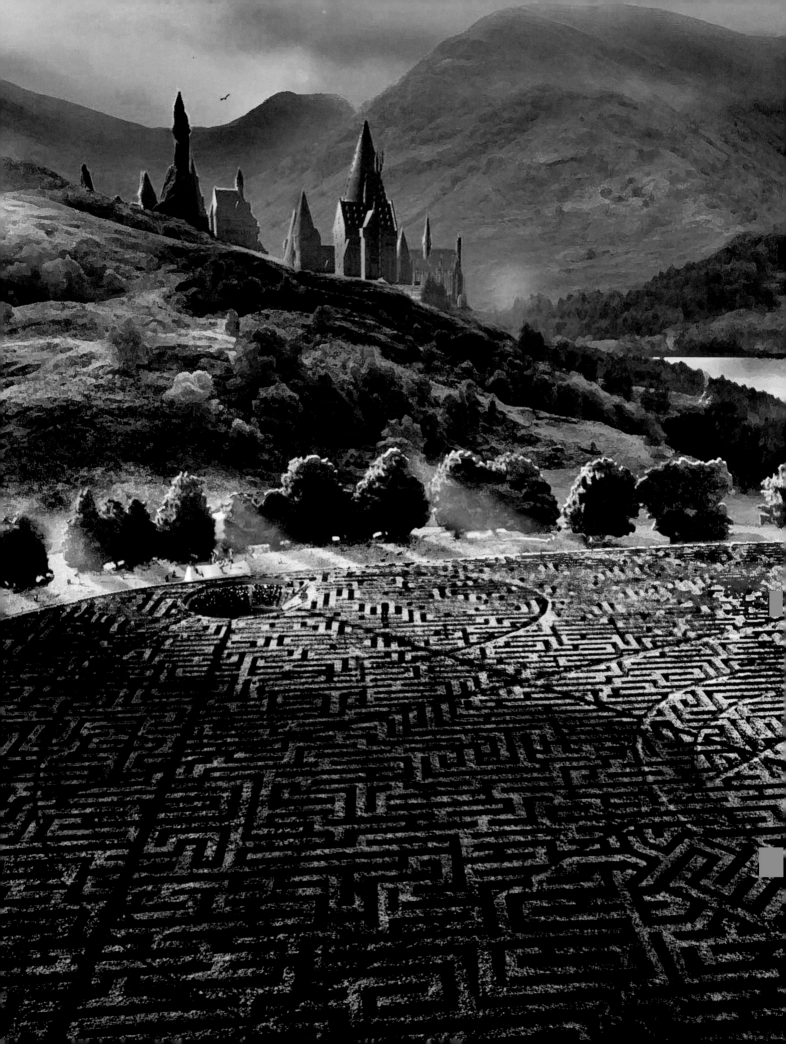

INTRODUCTION

In his first flying lesson at Hogwarts, seen in *Harry Potter and the Sorcerer's Stone*, Harry Potter demonstrates such natural ability at flying on a broom that it secures him a place on the Gryffindor Quidditch team, where he is the youngest Quidditch player on a house team in a century. The wizarding sport made absolute sense in the books written by J. K. Rowling, but bringing it to the screen required a bit of education for some.

"The most intense pressure I had as a filmmaker was trying to figure out how Quidditch worked," confesses *Sorcerer's Stone* and *Harry Potter and the Chamber of Secrets* director Chris Columbus. "We had to approach it as if the audience was watching an NFL game for the first time. The rules needed to be absolutely clear." In order to grasp the rules of the game, Columbus and screenwriter Steve Kloves met with Rowling. "J. K. Rowling came up with a chart for me," Columbus says, "giving me the rules of Quidditch to incorporate into the film." Working with the author, Kloves found a Muggle parallel that helped him gain insight into the sport. "She gave me a little bit of a clue in saying that she likes American basketball," he explains, "so I understood some of what she was doing with hoops and things." Columbus believes that the trio came up with rules that hadn't appeared in the first book. "And by the time we got through those meetings," he says, "we all understood the game."

To Columbus, it was important that Quidditch felt "dangerous, that it felt fast, and that—for lack of a better word—it felt *cool*. You wanted every kid who saw the movie to say, 'That would be my favorite sport, if I could play any sport.'"

PAGE 2: The first Golden Snitch Harry Potter caught during his time as a Seeker at Hogwarts; OPPOSITE: Concept art of the maze for the third task of the Triwizard Tournament by Andrew Williamson for *Harry Potter and the Goblet of Fire*; BELOW: Harry Potter learns about the Golden Snitch from Gryffindor Quidditch captain Oliver Wood in *Harry Potter and the Sorcerer's Stone*.

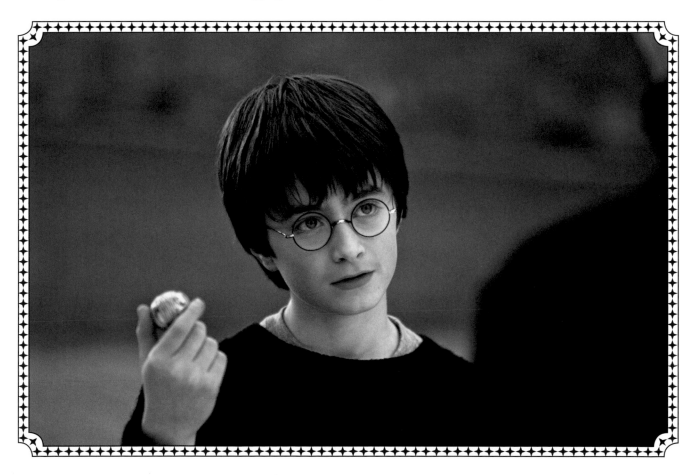

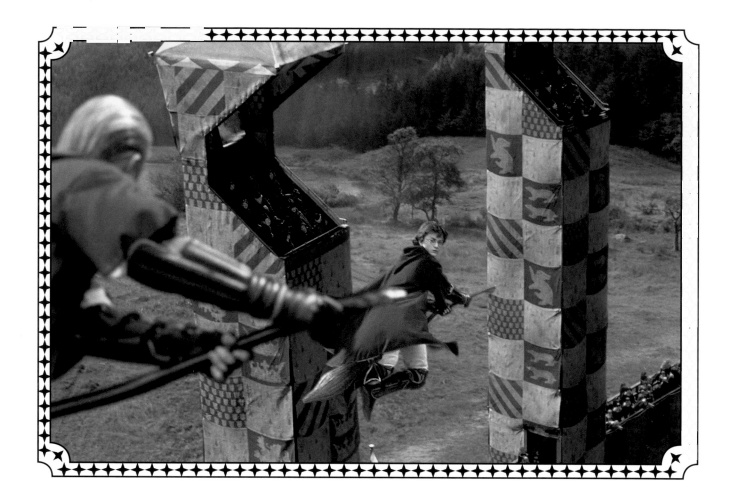

The sport is made up of many different elements: flying brooms; players zooming past tall towers with their cloaks flapping in the wind; balls of different sizes, shapes, and sounds. "Riding those brooms was a tremendously difficult thing," adds Columbus, "but to create a sense of movement, a sense of urgency, and, at the same time, to *feel* as if these were real athletes playing a game, was the biggest challenge." And Quidditch is an inherently dangerous sport. "Brutal," in fact, as Beater George Weasley tells Harry in *Sorcerer's Stone*, "but no one has died in years." The perils of the sport made the matches a ripe opportunity for Dark forces and others to make disguised attacks. Professor Quirrell casts a jinx to throw Harry off his Nimbus 2000 broom in *Sorcerer's Stone*, which leaves the Seeker hanging in the air until Hermione Granger is able to help him. A rogue Bludger, tampered with by Dobby the house-elf, hits and breaks Harry's arm when it attacks him in *Chamber of Secrets*.

TOP: Harry Potter is pursued by Slytherin Seeker Draco Malfoy in a film still from *Harry Potter and the Chamber of Secrets*; LEFT: Blueprint for Harry's Firebolt broom, a gift from his godfather Sirius Black; OPPOSITE: Concept art by Adam Brockbank for *Harry Potter and the Prisoner of Azkaban* depicts the Quidditch pitch during a driving rainstorm.

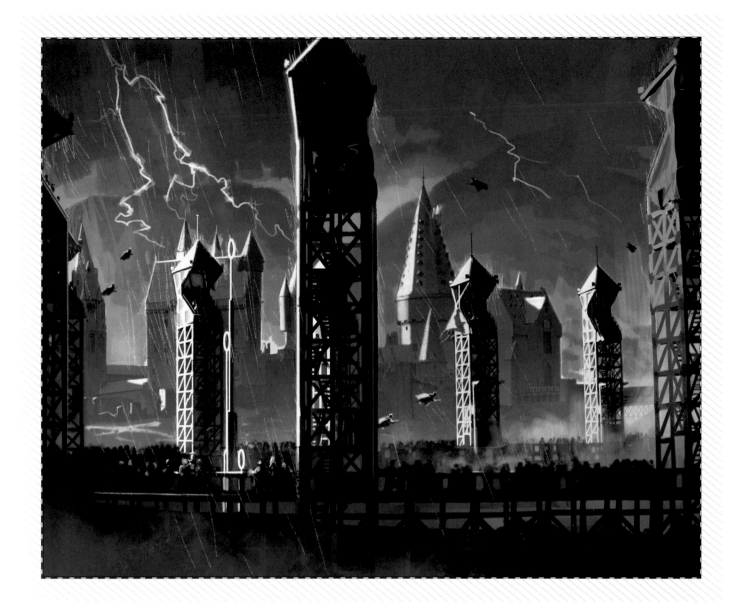

The Quidditch match between Gryffindor and Hufflepuff houses in *Harry Potter and the Prisoner of Azkaban* added new dimensions to the game. This Quidditch match takes place in a storm, with driving rain pelting the players, lightning flashing, and Dementors circling above the pitch. The characters, wetted down to appear soaked, were filmed independently, as the environment needed to be entirely created in the computer.

"[Director] Alfonso Cuarón wanted to make this [match] less of a game, because it is as much about the Dementors," says visual effects supervisor Tim Burke. Despite the inclement weather and his glasses icing up in the cold, Harry spots the Snitch and chases it into the clouds. Finding himself alone, he is attacked by Dementors. "It becomes Harry against the Dementors," Burke continues, "and that extra layer you go through is the excitement of the whole sequence." Affected by the ghastly creatures, Harry takes a fall, and his Firebolt broom is destroyed.

Harry Potter and the Goblet of Fire begins with the 422nd Quidditch World Cup, but Quidditch at Hogwarts is canceled when the dangerous Triwizard Tournament is reinstituted at the school after hundreds of years. The Tournament, attended by two other wizarding schools, is sabotaged whenever possible by followers of Voldemort, who manage to have Harry chosen as one of its champions. Harry is able to complete the three tasks of the competition—his broom work being an important factor in evading a dragon—but the result of his success is a calculated and grim wand battle with the Dark Lord.

Quidditch at Hogwarts returns in *Harry Potter and the Half-Blood Prince*—but this time the emphasis is less on danger and more on fun. "Comedy Quidditch had never been done before," says director David Yates. Much of the comedy comes from Ron Weasley's tryouts for the team, despite his overwhelming lack of confidence. "He's terrible at Quidditch," says Yates, "but his biggest flaw is he's crippled by fear. Anyone who's crippled by fear, it just stops them doing what they can be good at. So, poor old Ron." Ron Weasley's love for the game is apparent from the start, and he finally becomes a star player. As he says to Harry in *Sorcerer's Stone*, "Quidditch is great. Best game there is!"

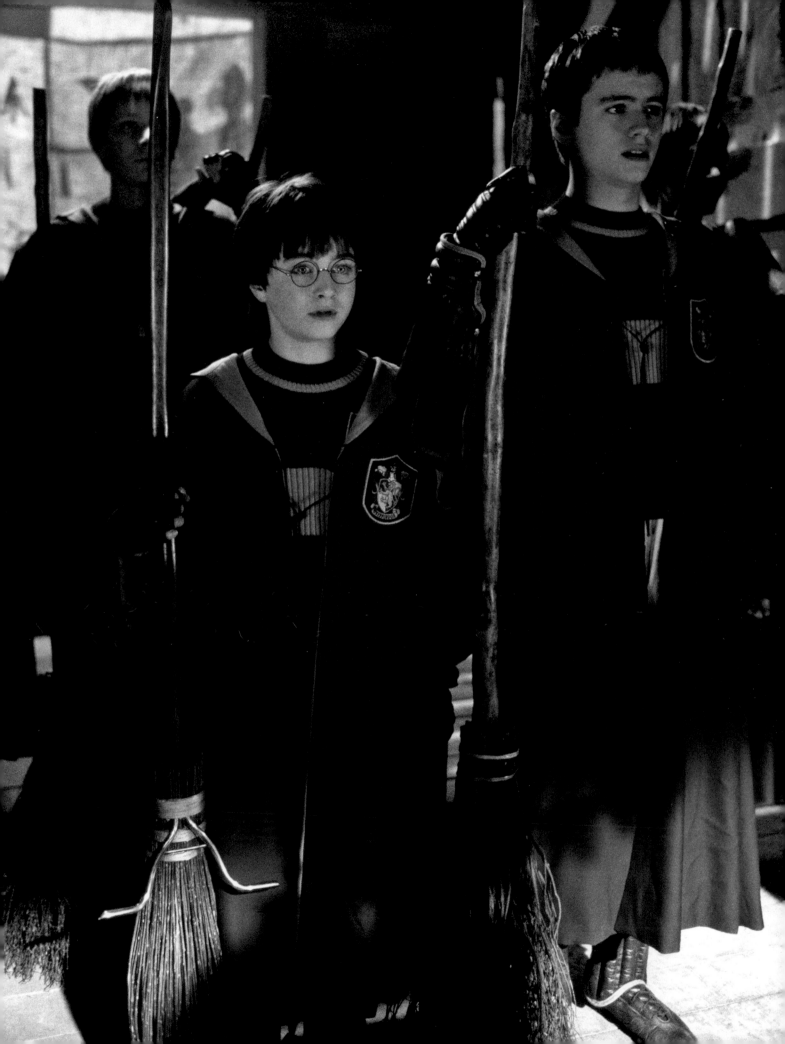

CHAPTER 1
QUIDDITCH

*"The Quaffle is released, and
the game begins!"*

—Lee Jordan, *Harry Potter and the
Sorcerer's Stone*

"Quidditch is great. Best game there is!"
—Ron Weasley, *Harry Potter and the Sorcerer's Stone*

The popular wizarding sport of Quidditch plays an important role in Harry Potter's story. The game's object is to score the most points by shooting a Quaffle through one of three hoops, or by catching the Golden Snitch. On each team of seven players, there are three Chasers who try to score goals with the Quaffle, two Beaters who hit two Bludger balls at the opposing team and keep the other team's Bludgers away from their own team, a Keeper who guards the goal posts, and a Seeker, whose job it is to catch the Golden Snitch. Harry's natural skill at riding a broom—first seen when he retrieves a Remembrall tossed into the air by Draco Malfoy in *Harry Potter and the Sorcerer's Stone*—leads him to become, as Ron Weasley informs him, "the youngest Seeker in a century" in the school's history of the sport. Harry's talent is brilliant, even though he catches his first Golden Snitch with his mouth, an important story point that doesn't pay off until the last film.

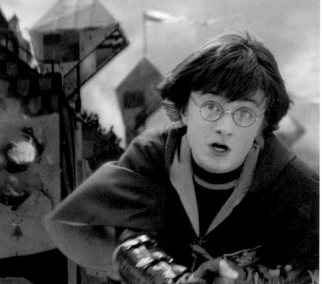

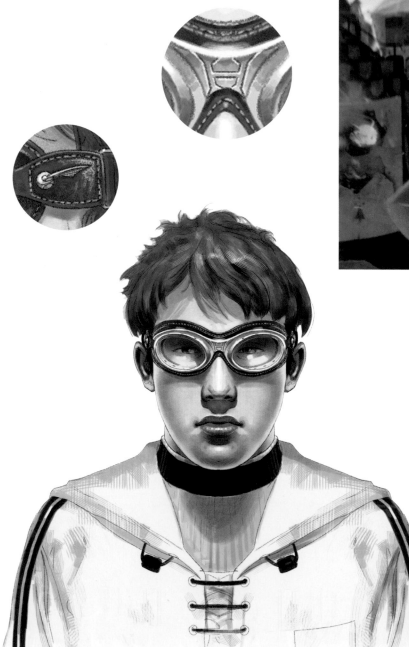

ABOVE: Harry Potter flees a rogue Bludger in *Harry Potter and the Chamber of Secrets*; LEFT: Adam Brockbank's concept art for a pair of goggles to be worn when inclement weather impeded the Quidditch matches; OPPOSITE: Concept art by Adam Brockbank of the Quidditch pitch with banners flying in the wind, for *Harry Potter and the Chamber of Secrets*.

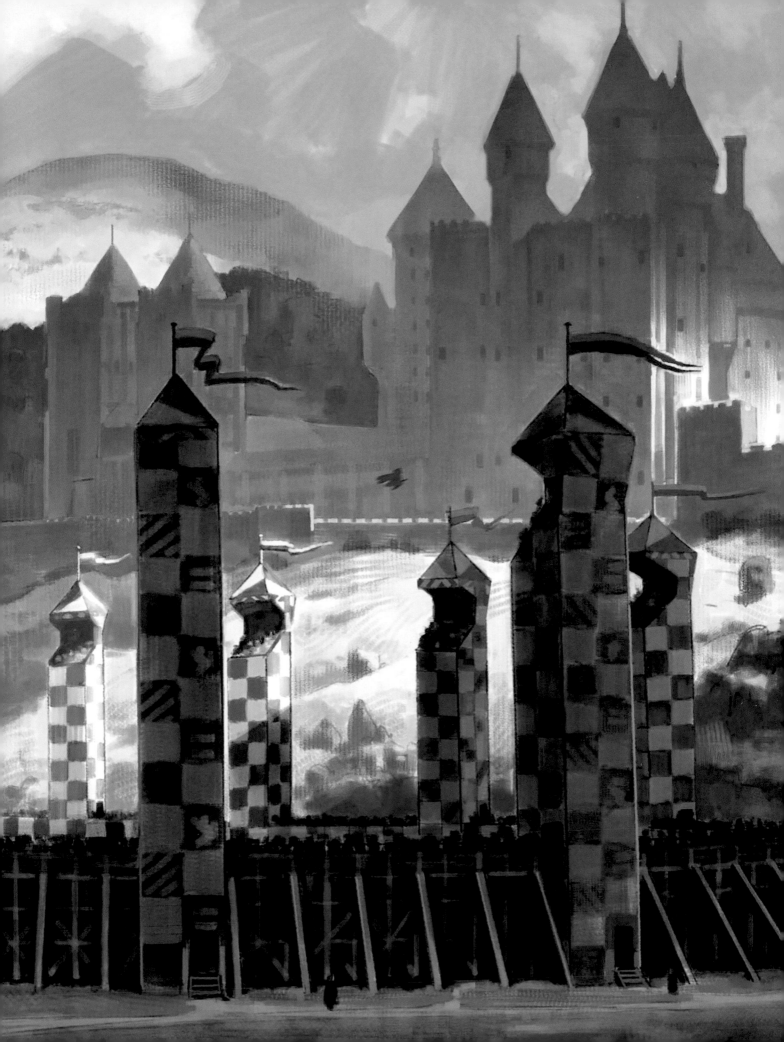

QUAFFLES AND BLUDGERS

"Bludger. Nasty little buggers."

—Oliver Wood, *Harry Potter and the Sorcerer's Stone*

In the real world, a Quaffle would appear to be sort of a cross between a basketball and a soccer ball. Production designer Stuart Craig sketched out concept art for all the Quidditch equipment, including size (a nine-inch diameter for the Quaffle) and texture ideas, and then the prop makers took the approved designs and turned them into working sports equipment. The four Quaffles that were created for the films had a red-colored leather cover wrapped over a core of foam. The stitching was concealed, and a Hogwarts crest logo was debossed on the opposite sides of the ball, faded and scratched up from years of use.

Bludgers are intended to be much heavier than Quaffles. The small black spheres are quick, dense, and very dangerous, as they are whacked by the Beaters with short wooden hand bats. "Bays," which are special arm guards used in cricket matches, were an important safety feature of the players' uniforms. The bays started at the shoulder and went down to the wrist. As play became more aggressive through the years, more and more uniform padding and even a helmet were added.

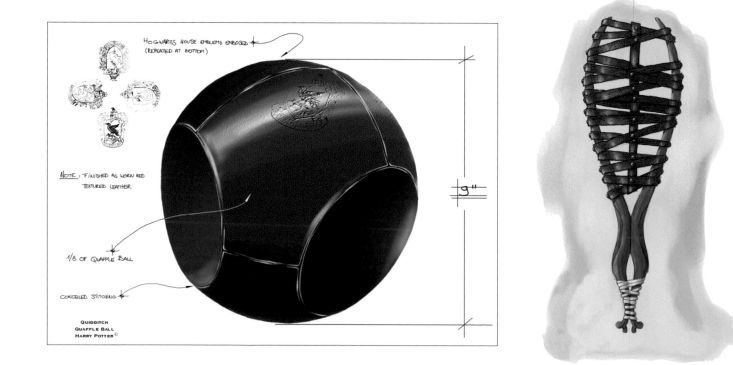

HOGWARTS HOUSE EMBLEMS EMBOSSED
(REPEATED AT BOTTOM)

NOTE: FINISHED AS WORN RED
TEXTURED LEATHER

9"

1/8 OF QUAFFLE BALL

CONCEALED STITCHING

QUIDDITCH
QUAFFLE BALL
HARRY POTTER ©

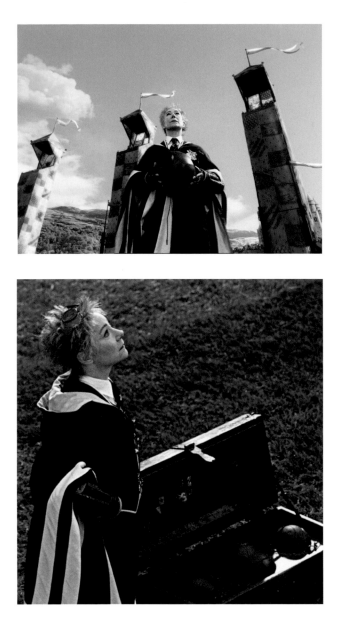

Each ball used in Quidditch needed to have its own sound as it flew through the air. Since the Quaffle is the biggest ball in the game, it makes a loud thunk when captured or hit by a player. The sound designers decided that since Bludgers were "nasty little buggers," as Gryffindor captain Oliver Wood calls them, they should sound like an angry animal when struck.

OPPOSITE TOP: *(left to right)* Concept designs for a Bludger, a Bludger bat, a Quaffle, a protective arm guard, and another Bludger; OPPOSITE BOTTOM LEFT: Detailed visual development art for the final iteration of the Quaffle indicates placement of the Hogwarts crest on the ball; OPPOSITE BOTTOM RIGHT: Design for a hand bat, by Stuart Craig and drawn by Gert Stevens; TOP LEFT AND LEFT: Madam Hooch (Zoe Wanamaker) referees a Hogwarts' Quidditch tournament and tosses up the first Quaffle; BELOW: Concept sketches for a trunk that holds the Quidditch equipment with chains that hold impatient Bludgers in place.

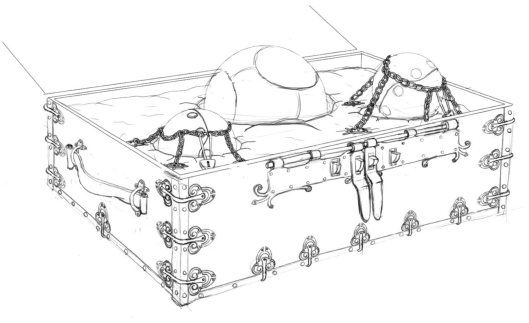

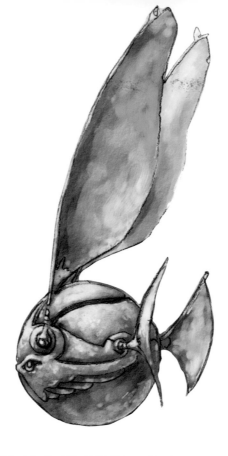

THE GOLDEN SNITCH

"The only ball I want you to worry about is this...the Golden Snitch."

—Oliver Wood, *Harry Potter and the Sorcerer's Stone*

The Golden Snitch flies around the Quidditch pitch with amazing speed, wings fluttering furiously as it darts up and down and side to side, eluding and teasing each team's Seeker. Various designs were considered for both the wings and the body of the Golden Snitch in order to give it credible aerodynamics; some wings were moth-shaped while others were sail-shaped, with ribs that went either horizontally or vertically across them. One Golden Snitch had rudders resembling fish fins. The walnut-sized ball of the Golden Snitch also went through several design iterations, but eventually the final prop included thin, ribbed wings in an abbreviated sail shape attached to an Art Nouveau–style body. The actual mechanics of the wings retracting and expanding were also important to the design. "In theory," says Stuart Craig, "the wings retract into the grooves on the sphere so that it reverts back to being just a ball." The multiple versions of the Golden Snitch prop were electroformed in copper and then plated with gold. However, it was the special effects team that made the Golden Snitch fly and the sound design team that gave the small, elegant ball a hummingbird-like sound. When needed, the computer artists also created a reflection of the Golden Snitch in Harry's glasses to make the illusion complete.

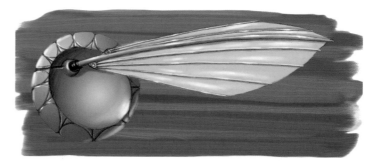

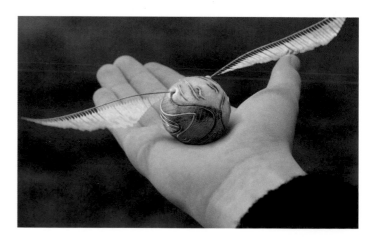

TOP AND ABOVE RIGHT: A hero prop for a true hero. Visual development art by Gert Stevens of the Golden Snitch for *Harry Potter and the Sorcerer's Stone* offered different possibilities for wing and rudder designs, and positions for how the wings would wrap back onto the ball; RIGHT: The Golden Snitch as seen in *Sorcerer's Stone*; OPPOSITE: The final Golden Snitch.

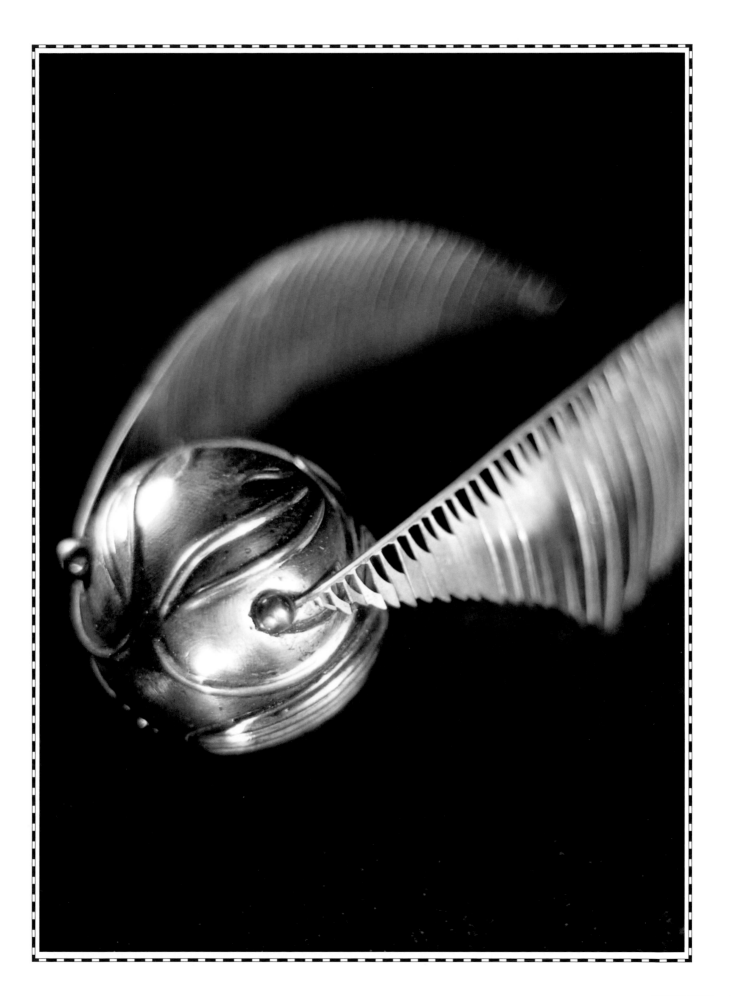

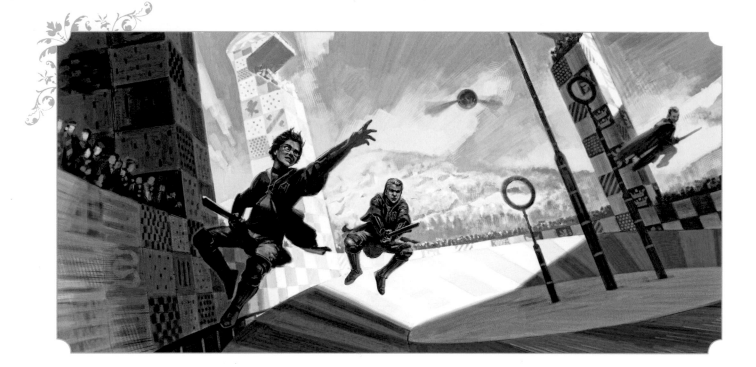

QUIDDITCH PITCH

OCCUPANTS: Madam Hooch, Quidditch teams

APPEARANCES: *Harry Potter and the Sorcerer's Stone, Harry Potter and the Chamber of Secrets, Harry Potter and the Prisoner of Azkaban, Harry Potter and the Half-Blood Prince, Harry Potter and the Deathly Hallows – Part 2*

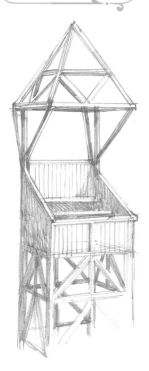

Harry Potter and the Sorcerer's Stone included the highly anticipated first view of the wizard game Quidditch. "Though we call it the Quidditch pitch, the game is not actually played on a pitch," says Stuart Craig. "It's played in the air. The pitch is just the takeoff point, really. So how do you make sense of a game that's played in the air when spectators are on the stadium's grounds?" Craig began doodling out his ideas and realized that towers were the obvious way to take the spectators up into a position where they could actually see the action. "There are two tiers of spectators," he explains. "The expensive seats are up in the towers, and the groundlings are down in terraces on the ground. But that gave the stadium a very distinctive look: a ring of bleachers and a high circle of towers." He further reasoned that as Hogwarts was set beside an endless forest, the stadium would be constructed out of the local timber. And while the towers would certainly sport the house colors of the four Quidditch teams, the design of the arena would have the feeling of a medieval tournament, inspired by the age of the castle, complete with heraldic-looking banners.

"The pitch was huge, so we couldn't possibly fit it in any stage at the studio," explains Craig. "It could fit on the back lot, but there wasn't much point, since the background needed to be the Highlands of Scotland. And, of course, it would have been *hugely* expensive and inconvenient to go and build it in Scotland, so, inevitably, it became one of our first almost entirely computer-generated sets." As needed, sections of the stadium were built for live-action shots, including at least one base and lower stand as well as a tower top.

As the films continued and the athletes got older, the game became more extreme. Dementors and dangerous weather elements caused trouble in *Harry Potter and the Prisoner of Azkaban*. For *Harry Potter and the Half-Blood Prince*, Craig re-created the stadium for what he called "super-deluxe Quidditch." The mountainous backdrop was brought closer, and the surrounding meadow shrunk down. The towers were heightened and more were added, which forced the towers closer together. The bleachers were reconfigured from one basic box to tiered stands. Craig notes, "In addition to a redesign that I felt was smarter and more impressive, now Ron was playing." Director David Yates wanted "comedy Quidditch" for the last time the game would be seen on-screen. "By introducing more towers, there were more opportunities for weaving in and out of them, and more things whizzing by in close proximity gives a greater sense of speed, so the changes were really required," Craig says.

Prior to Ron Weasley's Quidditch debut, the tryouts and practice matches for the Gryffindor team were seen, for which Craig gave the stadium a different look. "The trials, the practices, wouldn't have all the colorful fabric. For this we changed it to a sort of skeletal wood form." Sadly, in *Harry Potter and the Deathly Hallows – Part 2*, the Quidditch pitch is seen as Voldemort's followers burn it to the ground.

THESE PAGES: *(clockwise from top left)* Art shows Harry Potter reaching for the Snitch in a Quidditch match against Slytherin; the two teams make their way to the pitch; a sketch of the stands by Stuart Craig.

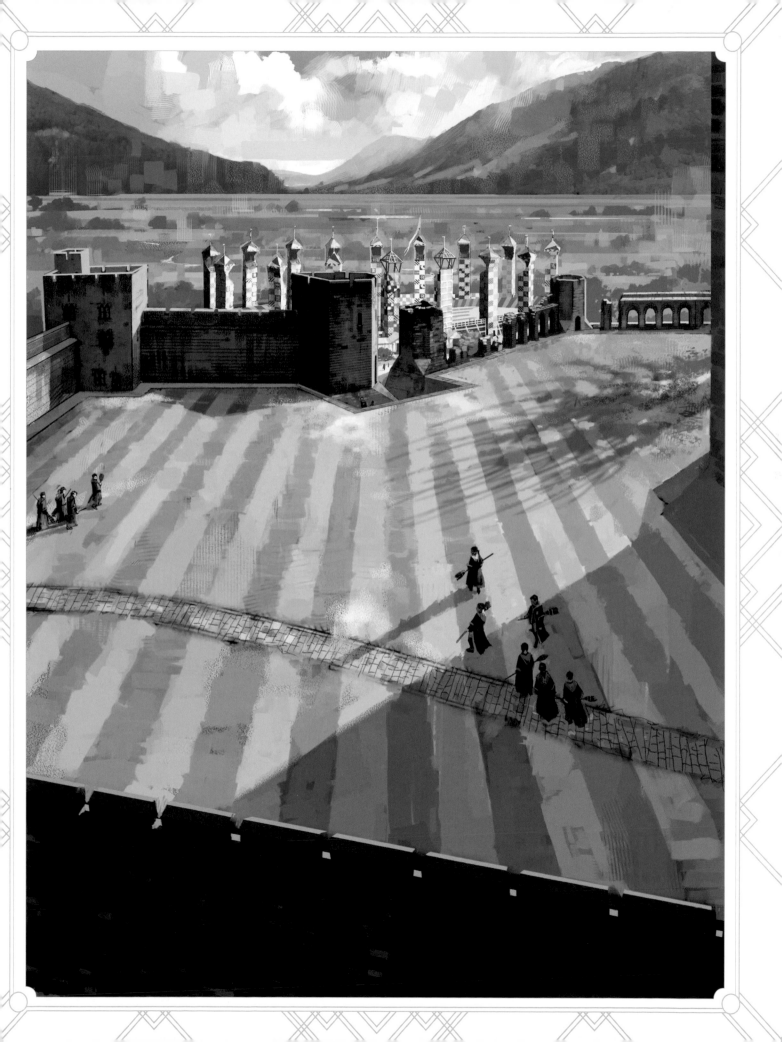

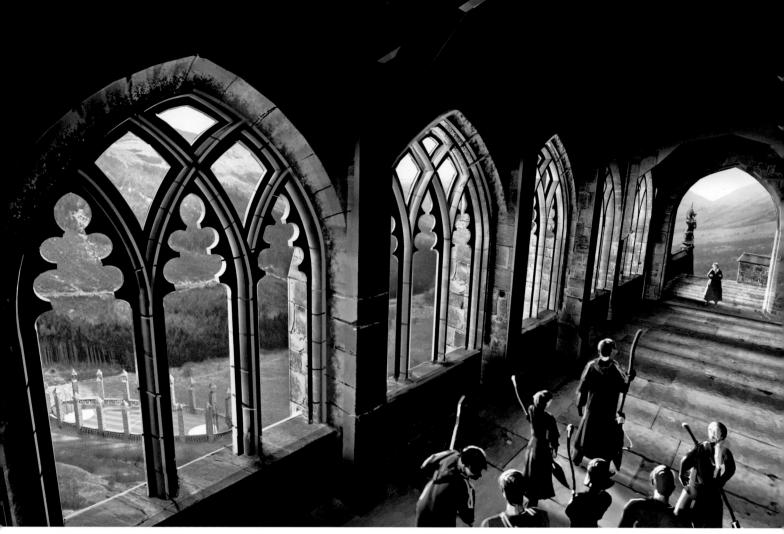

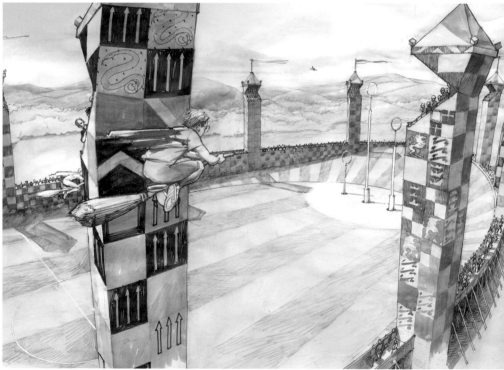

THESE PAGES: (clockwise from top left) Art by Andrew Williamson for a scene that was never filmed; concept art of the Quidditch pitch; Harry and Draco chase the Golden Snitch in art by Adam Brockbank; unlike in the books, the Quidditch pitch in the films is adorned with all the school colors; professors look on from the stands.

"Our job is to make sure that you don't get bloodied up too bad. Can't make any promises, of course. Rough game, Quidditch."

—George Weasley, *Harry Potter and the Sorcerer's Stone*

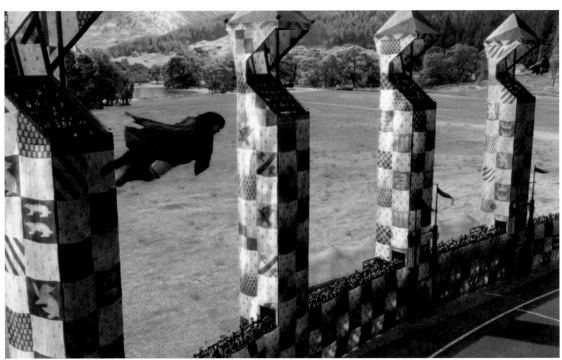

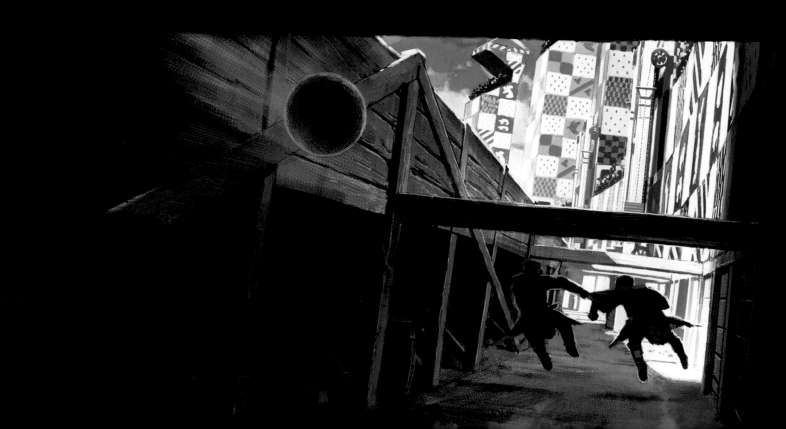

QUIDDITCH SPORTSWEAR

In *Harry Potter and the Sorcerer's Stone* and *Harry Potter and the Chamber of Secrets*, the Quidditch uniforms designed by Judianna Makovsky followed her "scholastic wizardry" philosophy, striving to evoke timelessness combined with familiarity. Sporting their house colors, the players wore crew-necked sweaters under a laced-up modified version of the school robes. Their white breeches bring fencing garb to mind, and their boots and arm and leg guards are reminiscent of nineteenth-century cricket and polo wear. The leg guards, made of thick leather with a canvas lining, had reinforced padded knees with a softer leather cover and buckles on the back. And, Makovsky recalls, "We discussed at length whether to have wizard gowns or not, but they flutter nicely and they *are* in the book."

As the films became darker and the Quidditch play became rougher, the uniforms were redesigned. For *Harry Potter and the Prisoner of Azkaban*, Jany Temime wanted to update the outfits so that they were more relatable to kids who were fans of present-day sports. Given that the Quidditch game took place in stormy weather, she chose a water-resistant nylon fabric and added goggles that helped modernize the look. She also added piping and numbers to the backs of the robes, though these were assigned randomly. Faster and more defensive play encouraged a redesign to ensure comfort and safety as the actors sat on their broomstick rigs, harnessed in front of a green screen. Unseen under their robes, bicycle-type seats were affixed to the brooms, gussets were added to seams, and padding was added to the backside of the costume.

Harry Potter and the Half-Blood Prince brought what director David Yates called "comedy Quidditch," when Ron Weasley tries out and makes the Gryffindor team. For the Quidditch trials, the students wear what Temime describes as a warm-up suit featuring sleeveless tunics over gray hoodies, now sporting numbers that indicated a specific position. "Each number tells which

APPEARANCES: *Harry Potter and the Sorcerer's Stone, Harry Potter and the Chamber of Secrets, Harry Potter and the Prisoner of Azkaban, Harry Potter and the Goblet of Fire, Harry Potter and the Half-Blood Prince*

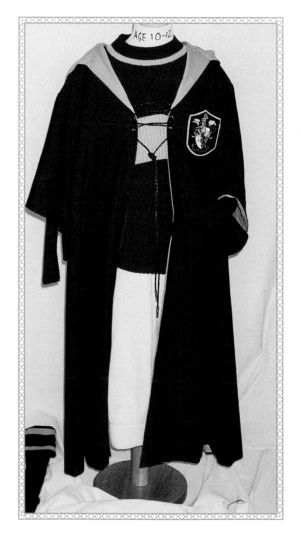

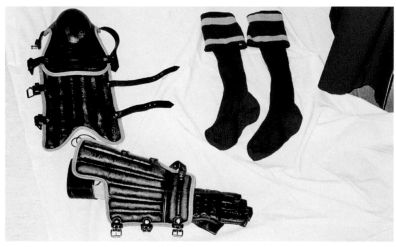

ABOVE: Jany Temime's update to the Quidditch uniform included stronger arm and leg guards based on 1930s American football wear; RIGHT: Costume reference shot of Gryffindor uniform for second years; OPPOSITE TOP LEFT: Oliver Wood (Sean Biggerstaff), Gryffindor captain; OPPOSITE TOP RIGHT: Jany Temime designed Quidditch practice wear for *Harry Potter and the Half-Blood Prince*, sketch by Laurent Guinci; OPPOSITE BOTTOM: A clash of Slytherins and Gryffindors from *Chamber of Secrets*.

> "Rough game, Quidditch."
> "Brutal. But nobody's
> died in years!"
>
> —George and Fred Weasley,
> *Harry Potter and the Sorcerer's Stone*

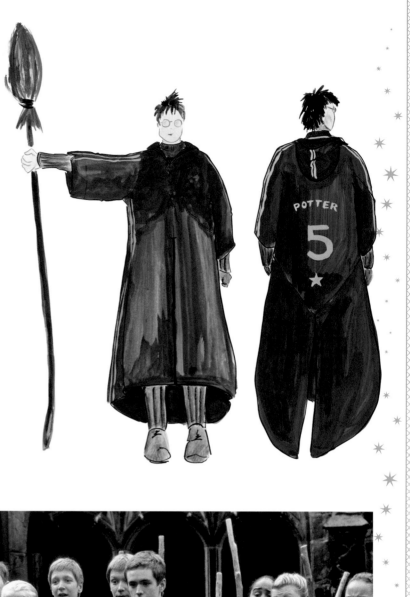

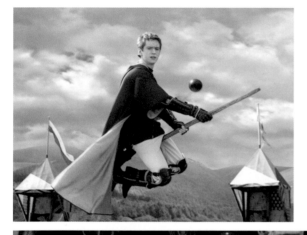

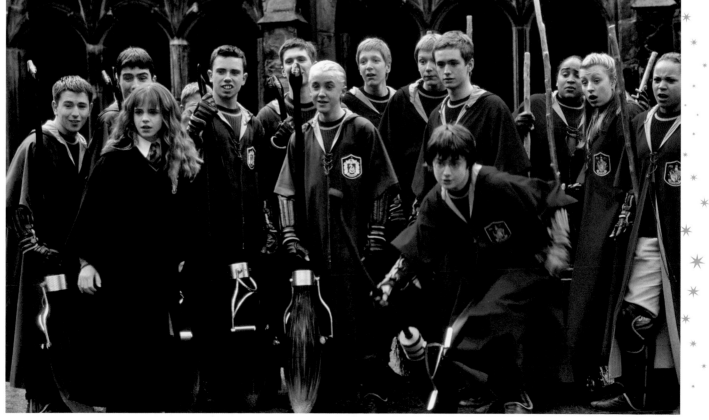

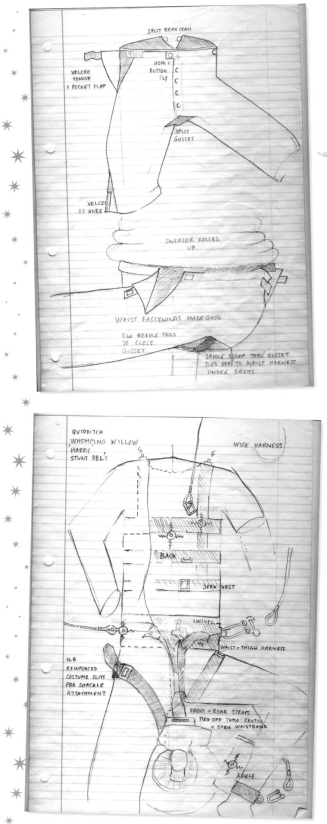

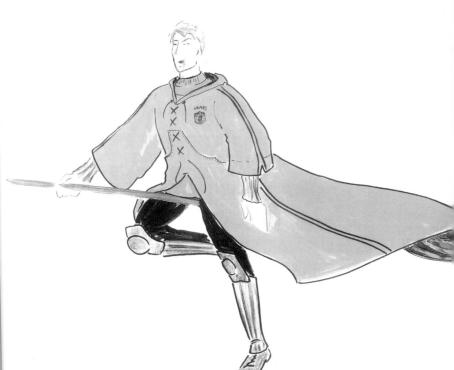

position you are playing, whether you're a Beater or a Seeker or a Keeper," explains Temime. "In tryouts, you put on the number of the position you want." Keepers were 2, Seekers were 7. During the game, the wool sweaters were now covered by a streamlined lightweight tunic protected by shoulder, arm, and leg guards. These were created from pieces of leather that were soaked in water and then placed in a mold. Special attention was paid toward designing the safety gear with multiple articulations so that no guard piece locked to another during the intricate stunts. The molds proved beneficial when costumer Steve Kill was asked to create a pile of uniform pieces seen during Quidditch trials; these were produced in a foam rubber plastic. Helmets were added to the uniforms, based on early American football gear. Temime wanted to give the Slytherin robes more of a militaristic feel, and so, to a darker green than seen in previous uniforms, she added silver stripes and black stars. Additionally, the inside of their robes was lined with a shiny material to make them appear more luxurious.

The proportions of the Quidditch uniforms were played around with depending on the character. Actors Rupert Grint, as Gryffindor Keeper Ron Weasley, and Freddie Stroma, as wannabe Keeper Cormac McLaggen, are roughly physically the same size; the filmmakers wanted Stroma to appear bigger. Stroma's shoulder guards were scaled up, and extra panels were added to the front and back of his uniform to give him a bigger silhouette. In contrast, and because Ron once again ends up with hand-me-downs, his uniform was constructed on the small side, and sandpaper was used to scuff up the leather and laces.

And for the first time in the films, fan wear was created for the nonplaying students to support their teams. These track-style T-shirts and hooded sweatshirts were made in the four house colors and were "branded" with the Hogwarts crest. They were accompanied by sweat pants in grays and blacks.

LEFT AND TOP LEFT: Diagrams explain the Quidditch costumes' redesign for comfort, and methods of harnessing the outfits for stunts; TOP RIGHT: Hufflepuff uniform for *Harry Potter and the Prisoner of Azkaban*, sketch by Laurent Guinci; OPPOSITE TOP:New Slytherin and Gryffindor practice wear for *Harry Potter and the Half-Blood Prince* was designed for more aggressive play, drawn by Mauricio Carneiro; OPPOSITE BOTTOM LEFT: Freddie Stroma and Rupert Grint in front of a blue-screen practice pitch; OPPOSITE BOTTOM CENTER: Ginny, Harry, and Hermione try to calm Ron's pre-game jitters; OPPOSITE BOTTOM RIGHT: Post-game celebrations showcase the "branded" fan wear Temime created for *Half-Blood Prince*; PAGES 24–25: Harry chases after the Golden Snitch in artwork by Adam Brockbank.

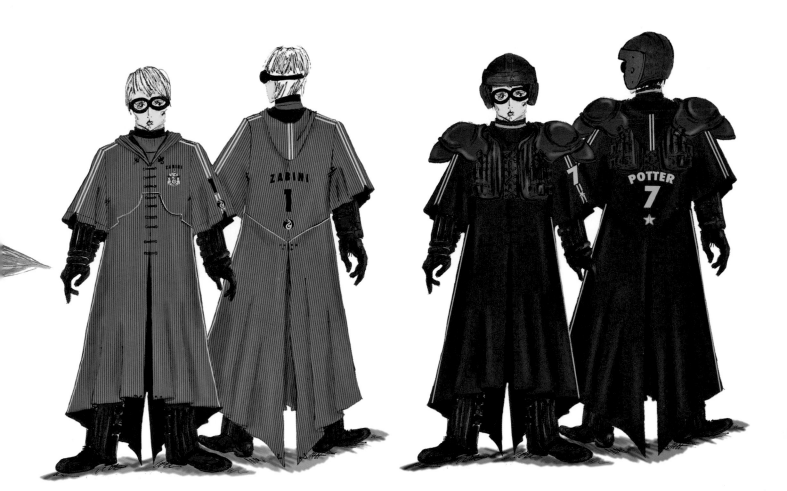

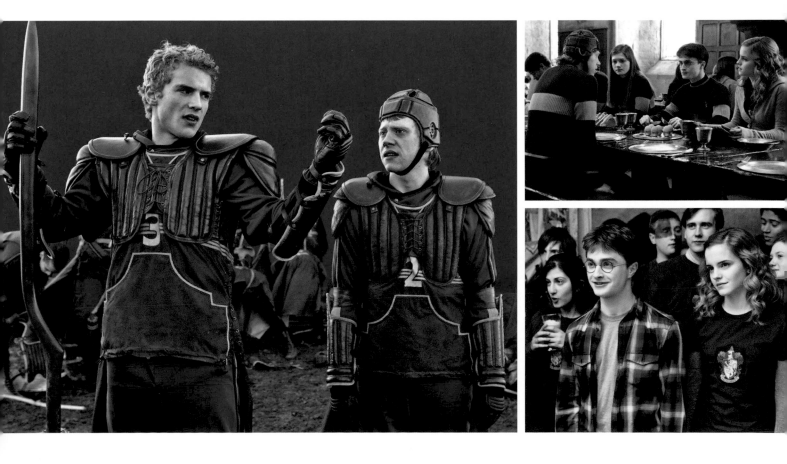

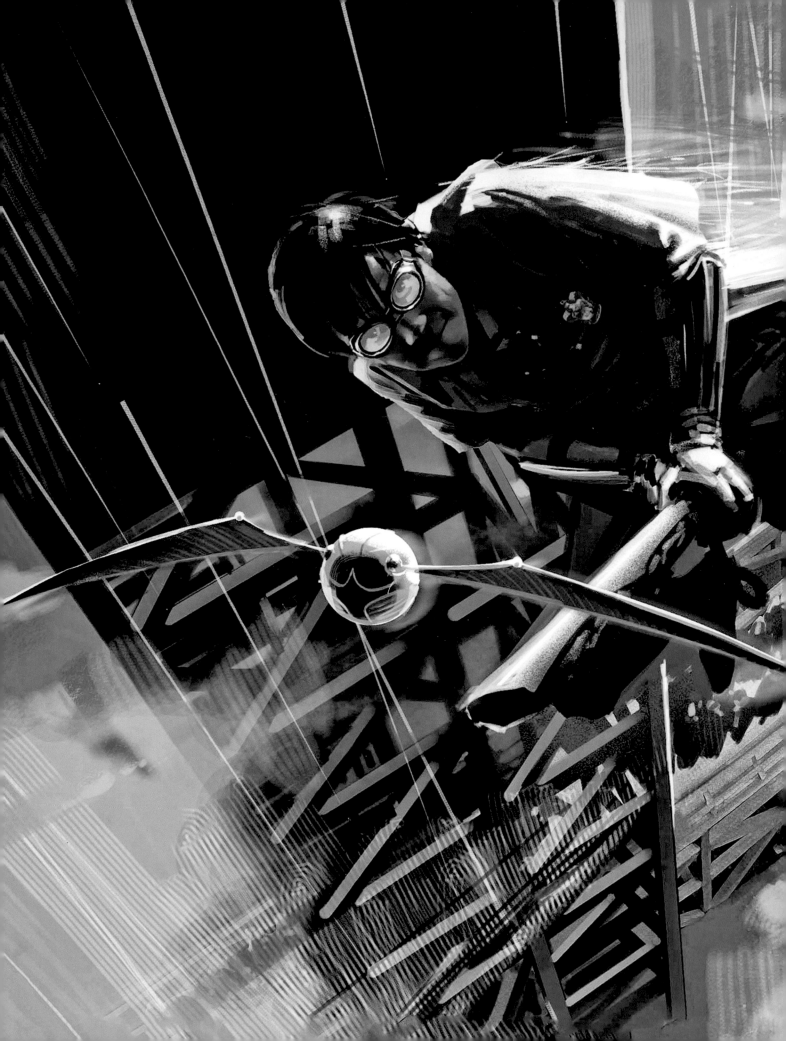

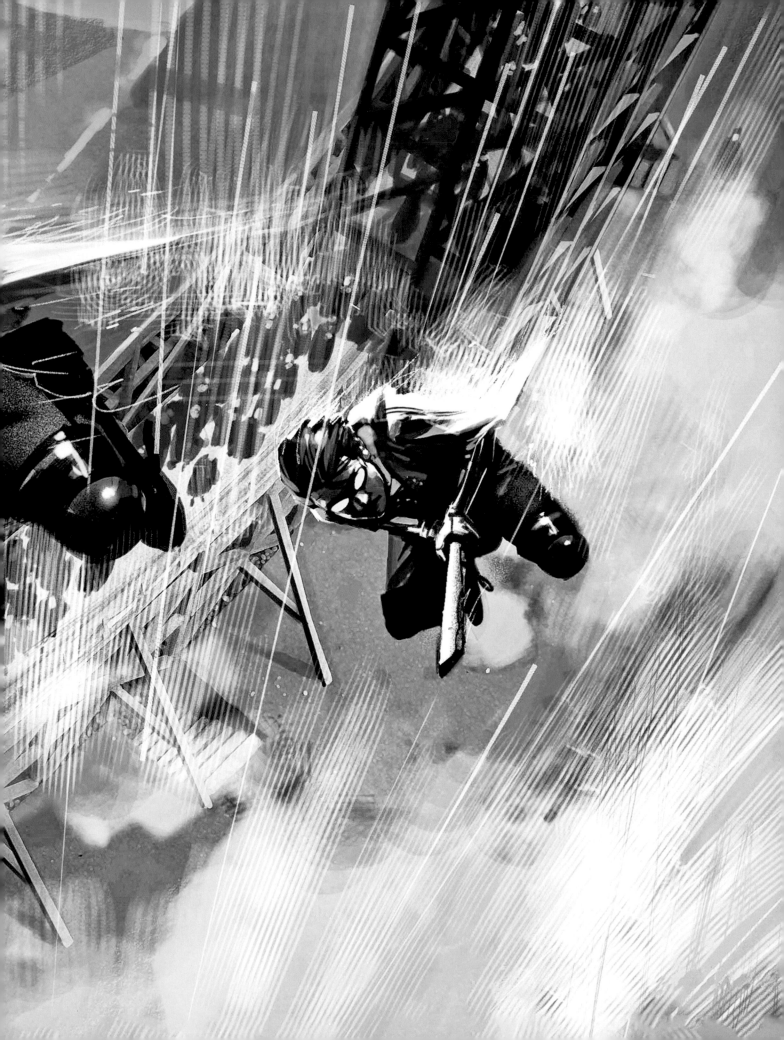

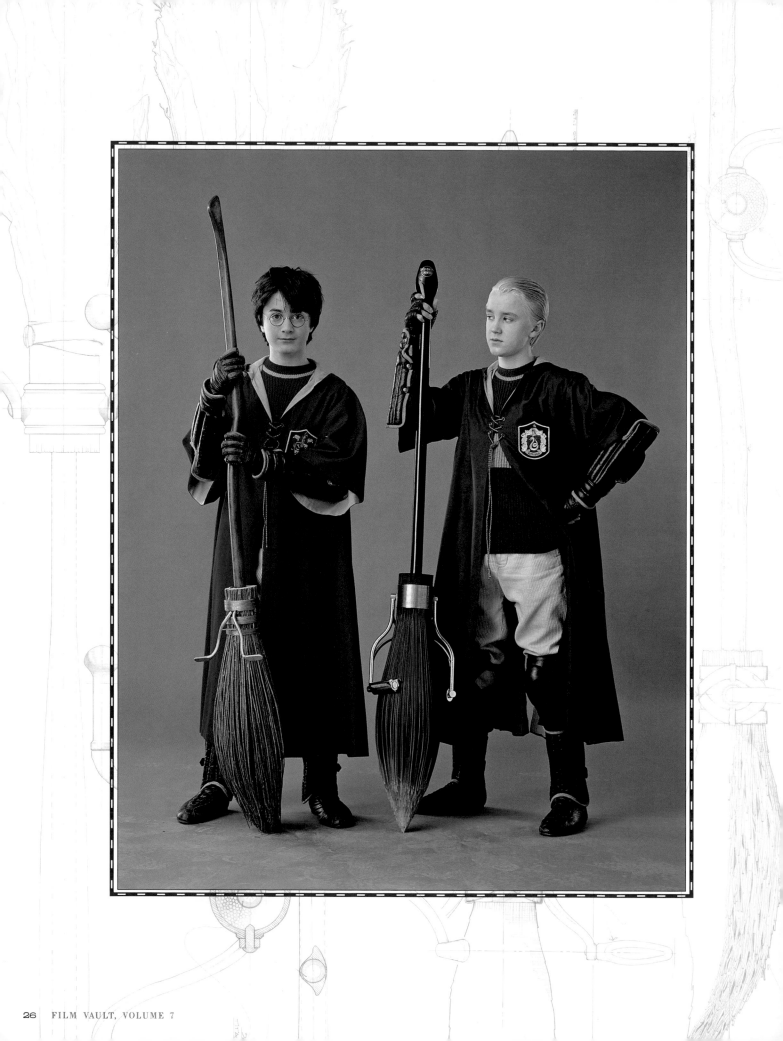

RACING BROOMS

If there's one artifact ubiquitous to a story set in a wizarding universe, it would be flying brooms. For Harry Potter, learning to ride a broom is akin to passing a rite of passage in the wizarding community, and excelling at playing their most popular sport, Quidditch, endears him to them and them to him. But leave it to the concept artists, designers, and prop makers to deliver a new twist to an old angle.

The brooms used by the young wizards in their first flying lesson at Hogwarts in *Harry Potter and the Sorcerer's Stone* seem as old as the school itself. They are knobby, crooked, and scraggly. But it shouldn't matter what the broom looks like; it's all about the skill of the rider, and Harry demonstrates immediately what a talented flyer he is. As a storytelling element, Harry's gain and loss of brooms in the story is a way to develop his character and his relationships: When Professor McGonagall observes Harry's natural abilities in his first flying lesson in *Harry Potter and the Sorcerer's Stone*, and he becomes the new Seeker for Gryffindor's Quidditch team, it is she who provides Harry with the best broom of the time: the Nimbus 2000. Similarly, when he loses that broom during a game in *Harry Potter and the Prisoner of Azkaban*, due to his vulnerability to Dementors, it is Sirius Black who gifts him with a replacement—an even better broom. The Firebolt his godfather sends him is a clear symbol of the affection in their new relationship.

Both the Nimbus 2000 and the Firebolt showcase the fine art of broom-making, with their aerodynamic construction and neatly trimmed bristle heads. But "these weren't just props that the kids carry around," explains Pierre Bohanna. "They have to sit on them. They have to be mounted onto motion-control bases for special effects shots, and twisted and turned to imitate flying, so they had to be very thin and incredibly durable." To keep the brooms lightweight but strong, an aircraft-grade titanium center was used in their construction. This was covered by mahogany wood, and then birch branches were added for the bristle head. The better the broom, the sleeker the branches. In order to make broom-riding more comfortable, for the third film, *Harry Potter and the Prisoner of Azkaban*, foot pedals were added, and bicycle seats, which were hidden by the player's robes, were attached to the brooms. (Also, padding was added to the rear part of the Quidditch uniform's pants.) The bicycle seats on the brooms were specially molded. "Every actor came in," recalls visual effects supervisor John Richardson, "adopted the flying position on their own broom, and we literally molded their bottom to suit, and then fitted that on the broom. So everybody that went on a broomstick not only had their own broom, they also had their own molded seat."

OPPOSITE: Daniel Radcliffe (Harry Potter) with a Nimbus 2000 and Tom Felton (Draco Malfoy) with a Nimbus 2001 show off their Quidditch brooms in a publicity still for *Harry Potter and the Chamber of Secrets*; OPPOSITE BACKGROUND: Blueprints for brooms used in *Harry Potter and the Half-Blood Prince* by Amanda Leggatt and Martin Foley; TOP: The Firebolt broom; ABOVE: Concept artist Dermot Power proposed debossing the Firebolt broom shaft with spell symbols in artwork for *Harry Potter and the Prisoner of Akzaban*.

FILMING QUIDDITCH

Before any Quidditch scene was filmed, every move was carefully planned out, from scoring a toss with a Quaffle to hitting a Bludger at the opposite team to racing after the Golden Snitch. Once the moves were plotted, stunt coordinator Greg Powell and his team of stuntmen and women would practice each one to make sure it made sense and could be done safely. Once the game play was cleared, the visual effects team would create an animated version of the game called a "pre-viz," short for pre-visualization. Pre-viz helps the FX team determine every element they will need to composite together to create the scene that will be seen on-screen. In addition to the players, this would include the Quidditch pitch towers holding the fans; the Scottish Highlands in the background; and Bludgers, Quaffles, and the Snitch.

The Quidditch scenes were filmed indoors in a room covered top to bottom in blue-screen material. During pre-viz, a list would be created for each player's moves, which were filmed one by one. Once the floor of the room was covered in airbags and pads (blue, of course), the actors were fastened into a harness before sitting on their brooms. Then they were strapped in so there was no chance of falling. After all this, they were raised into position to be filmed acting and reacting to the action around them. Some Quidditch scenes were so complex—with anywhere from two to fourteen players in the scene—they could take a week or two to film, and then visual effects would need more time to finish the scene, no matter whether it was on-screen for five minutes or five seconds.

For the first few films, Daniel Radcliffe estimates the actors were usually hoisted about eight or nine feet in the air to film Quidditch match flying. For one particular stunt in *Harry Potter and the Sorcerer's Stone*, however, Radcliffe was raised almost three times higher than that, to twenty-two feet. During Harry's first Quidditch game, his broom is jinxed by Professor Quirinus Quirrell (although Harry, Ron, and Hermione believed it to be Severus Snape who casts the curse). Harry struggles to hang on, so Radcliffe was suspended up in the air. "I was wired up to the broom with a huge airbag underneath me," Daniel remembers, "and they moved me around up there. That was brilliant!"

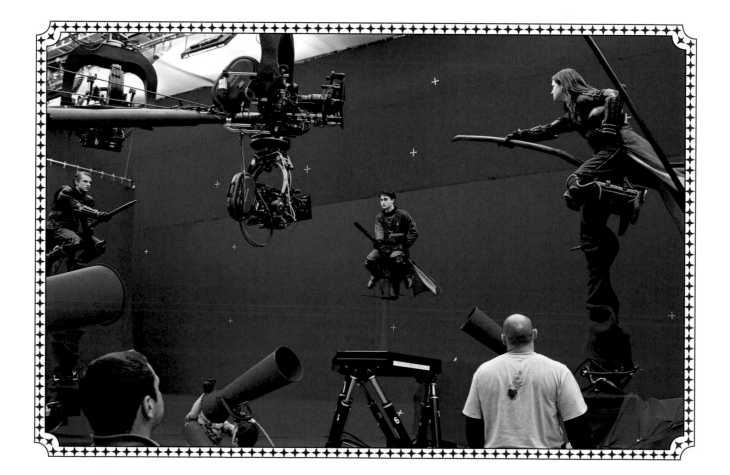

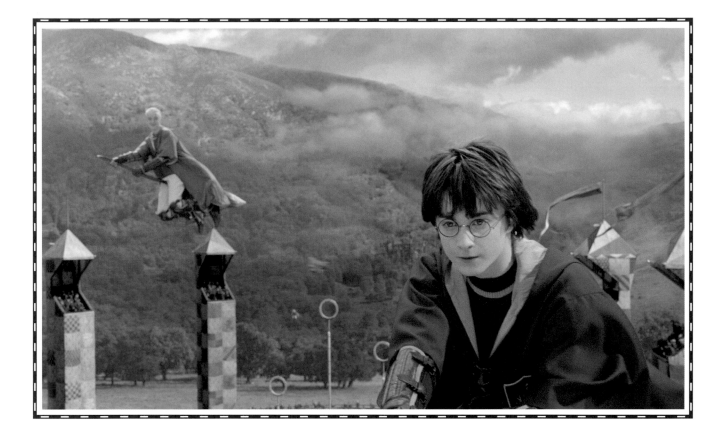

As the actors grew older and taller, they were all raised up about twenty feet in the air to film in front of the blue screen. In addition to wire work, there was another device that could make a broom "fly." An actor on his or her broom would sit atop a tall rig arm covered in blue-screen material. This arm was already programmed by a computer with all the necessary moves that had previously been plotted out for the scene: It would tilt or turn according to the predetermined action. Once again, the actor was strapped on very securely, so even if the rig turned upside down (which it could do), the actor would be safe. The camera filming these movements would be programmed to "fly" around the actor while they were "flying."

Anticipation for the Quidditch scenes was high, and the cast was told not to explain how the game or broom-flying was filmed. Whenever James and Oliver Phelps—who play the Weasley twins, Fred and George—were asked about it, they would either say that the actors were filmed on brooms while skydiving or while hanging from a rope that was hung out of the back of an airplane.

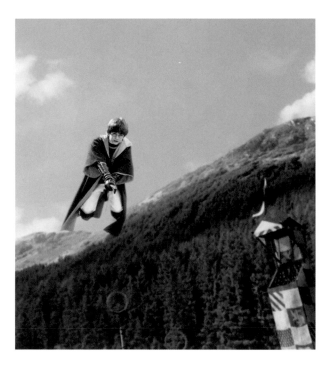

OPPOSITE: (*left to right*) Freddie Stroma (Cormac McLaggen), Daniel Radcliffe (Harry Potter), and Bonnie Wright (Ginny Weasley) await their "Action" cue as their brooms sit upon computerized rig arms in a specially prepared blue-screen room during the filming of *Half-Blood Prince*; TOP AND RIGHT: The finished Quidditch shots combined with CGI, set builds, and, for their first match in *Harry Potter and the Chamber of Secrets*, Quidditch Seekers Draco Malfoy (Tom Felton) and Harry Potter (Daniel Radcliffe) were filmed on rigs in a blue-screen room.

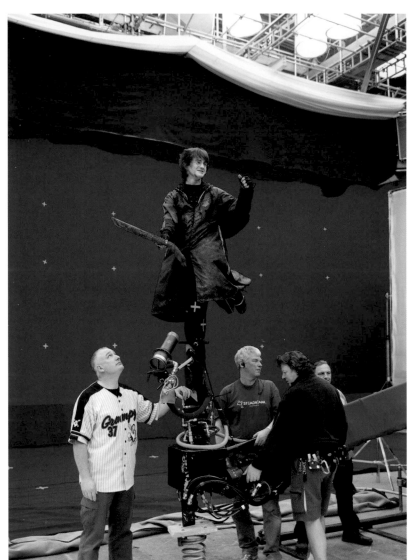

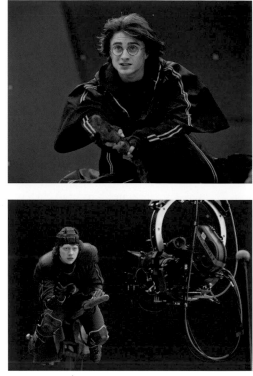

LEFT AND TOP: Daniel Radcliffe films a broom-flying stunt for *Harry Potter and the Goblet of Fire,* where his Quidditch skills were key to winning; ABOVE: Rupert Grint (Ron Weasley) films a Quidditch game move for *Harry Potter and the Half-Blood Prince.*

As technology improved during the course of the films, there was the possibility of bigger and wilder stunts during Quidditch games. One advancement was a wire grid system, which was added to the ceiling of the blue-screen room. Utilizing this system could not only add horizontal, vertical, and angled movements, but also helped the flying to look more natural whether the broom ride was smooth or bumpy. New equipment was created especially for the Quidditch flying seen in *Harry Potter and the Half-Blood Prince.* One piece was a very large, very powerful motion base that could rotate 360 degrees both horizontally and vertically and move up and down and in and out, all at the same time. "They could spin around one way and then the other way, and backward and forward," says special effects supervisor John Richardson. "It looks great, but I would hate to do it after lunch." For even bigger stunts, a large, mounted swing made of metal, which is used in circuses, allowed people to literally fly. As this "Russian swing," as it's called, would shift back and forth, a stunt person on a broom would launch into the air at the highest part of the arc to achieve heights of twenty feet and distances of forty feet while "flying" across a blue-screen set, allowing the camera to catch them in free fall.

Computer-created digital doubles of the actors permitted safer stunts and actions greater than the rig's abilities. "Inside a computer, we can do just about anything," says visual effects supervisor Tim Burke. "Moves in the game that would be impossible for an actor to perform can be made by a computer-generated version of the actor." The visual effects creators used a computer technology called videogrammetry to create the digital doubles. For this process, an actor sits on a chair with four cameras pointing at him or her; two in front—one shooting low, the other shooting high—and one on each side. Sixty-eight tracking markers are placed on their face to record its shape and skin textures. Then the computer artists assemble all this information to create a look-alike. Occasionally, the result was so realistic that the FX crew would get confused as to whether they were looking at a live actor or a digital double.

Other digital technological advances during the making of the later films made it possible for Quidditch to be more exciting than ever. For *Half-Blood Prince,* the players were filmed without their uniform cloaks—these were added in by the computer after filming was completed, in postproduction. The cloaks were made to flap and whip around and usually appeared

to be streaming behind the players, adding to the effect of speed. The visual effects artists also wanted to create the sense that the Quidditch game was being filmed just as a Muggle sport would be, with multiple, moving camera angles, including a flying cameraman. One way to really sell the illusion was that the snow that fell during the match appeared to hit the lens of the camera as it followed the action.

For the Quidditch tryouts in *Harry Potter and the Half-Blood Prince*, the stunt team invented new moves for director David Yates's desired comedy Quidditch. Crashes, falls, and other stunts became reference for action rendered either digitally or done practically. Another addition to Quidditch was Ron Weasley, who becomes Keeper of the Gryffindor team in his sixth year. To make actor Rupert Grint appear clumsy while filming his tryout, the stunt team fired up to twenty Quaffles at him at a time to fluster him, so that on-screen it seemed as if Ron was untalented and out of control.

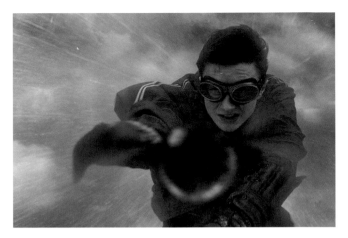

RIGHT AND BELOW: Dressed in Quidditch rain gear, Harry Potter encounters storm clouds and Dementors during a disastrous match in *Harry Potter and the Prisoner of Azkaban*.

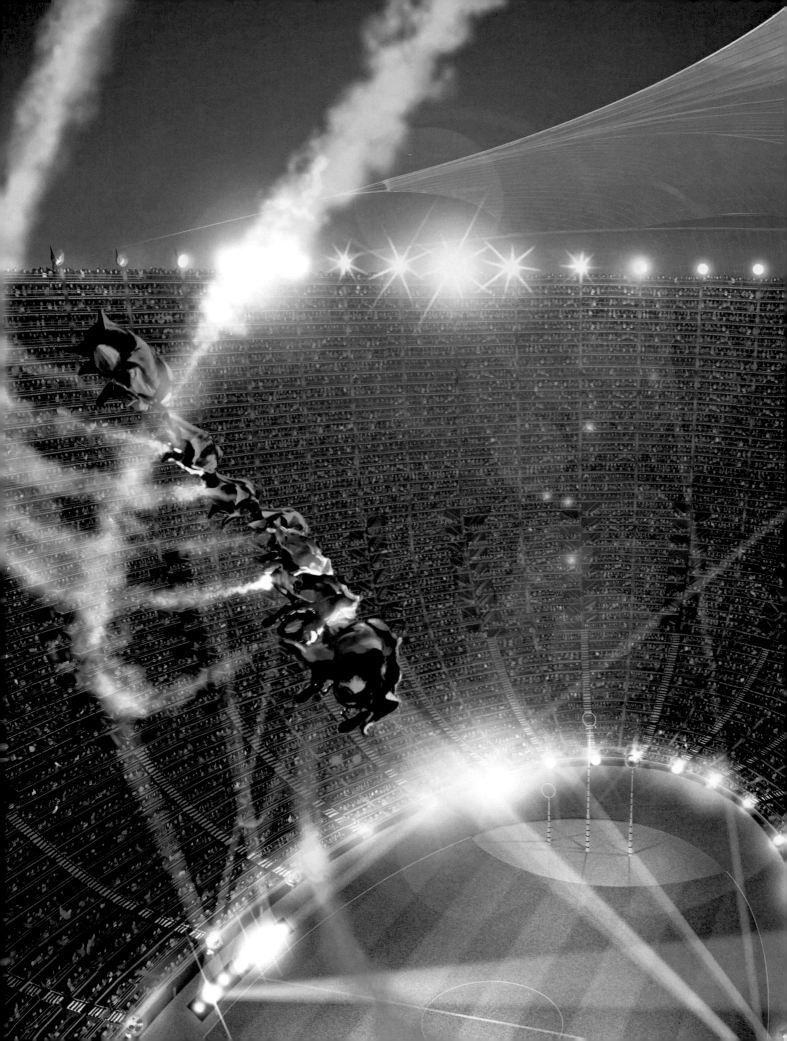

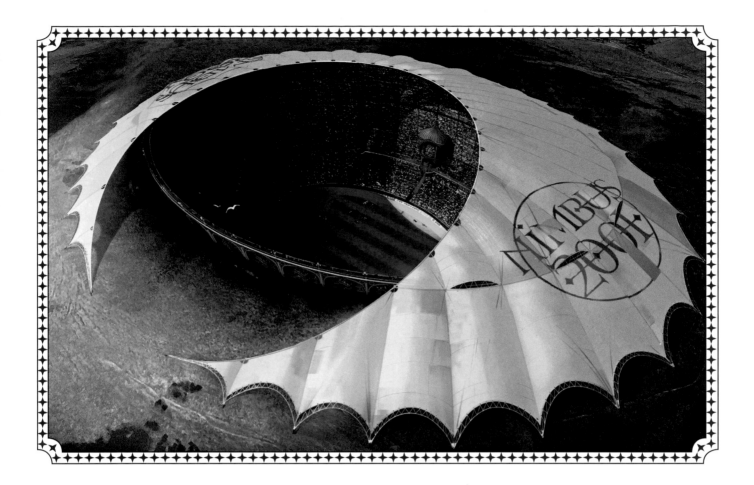

QUIDDITCH WORLD CUP

During his fourth year at Hogwarts, in *Harry Potter and the Goblet of Fire*, Harry is invited by the Weasleys to attend the 422nd Quidditch World Cup championship tournament. "I love it when the wizarding world butts up against the Muggle world," says producer David Heyman, "because it gives you that feeling that we may, just possibly, be living side by side with this parallel, unseen, magical society." *Goblet of Fire* offered Harry Potter fans and Harry Potter himself a growing view of the wider wizarding community. "Hogwarts is not an isolated school of witchcraft and wizardry, but one of several," Heyman continues. "And Quidditch isn't simply a game played at Hogwarts, but one that is so international that a Quidditch World Cup has been held every four years since 1473!"

Thousands of wizards attend the event, camping outside a massive stadium. The filmmakers had two important requirements for the location of the World Cup—it had to be invisible to the Muggle world, and it had to outdo by far the Hogwarts Quidditch pitch in size. So, the challenge was to find a location that would be able to hide a massive site from prying eyes. "We searched England for actual locations," says director Mike Newell. "We felt that you could only understand the scale of it if you actually set it as part of a landscape." Locations scouted included Dunstable Downs above London and the more southerly South

Downs National Park as well as Beachy Head, the highest chalk sea cliff in Britain, which is where the World Cup was placed.

"Beachy Head has that fantastic cliff, and then great swathes of green that swoop up and again," says Stuart Craig. "So, we decided that the campsite could be on this huge, green meadow. The cliff has two successive drops, and there's a plateau in between, so that could be where the wizards were camped." A series of tunnel entrances was positioned where the slope rises to the top level. "If you went through those tunnel entrances, you actually came out into the stands of the Quidditch stadium," Craig explains. "It's as if the Quidditch stadium was dug into the earth at the top level of Beachy Head, and therefore was completely invisible to passersby. Only accessible through these tunnels in the hillside." One of these entrances emerges into the back of the stands where the Malfoys meet the Weasley family on the staircase as they take their seats. Doing all this gave the arena a complete geography and logic to it.

As a rule, the filmmakers of the Harry Potter films first gave thought to how something could be done practically rather than digitally. "The instinct is always that you're going to do less CGI rather than more, because the cost is so huge," says Newell. "So, hey, why not hire the whole of the student body of the University of Sussex, trick them all out in costumes of various kinds, bus

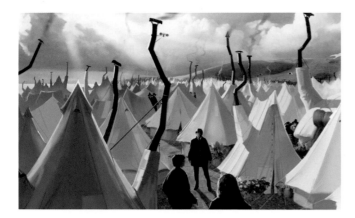

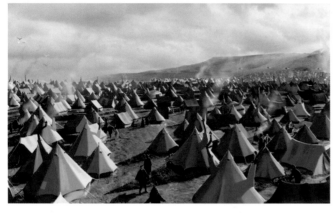

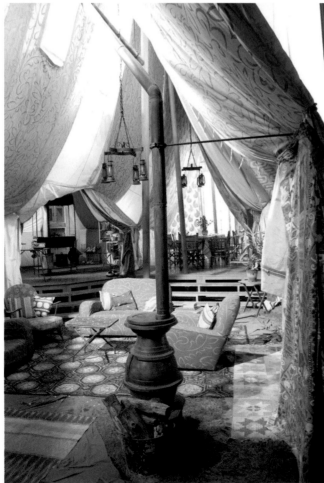

them out to Beachy Head, and shoot the establishing shots for that for real. It could actually be cheaper than doing it digitally." Then the reality of adding wizards who fly on broomsticks and team mascots walking around on stilts several stories high sets in. "So, if you're going to do that in CG, then in for a penny, in for a pound," he continues. "You might as well do the whole thing, at which point you just shoot the basic landscapes."

There were several sections of the stadium built at the studio: the official box where Cornelius Fudge opens the match; a small section of audience seating, filmed once with Bulgarian supporters and again with Irish fans; and the platform at the top of the stadium where Harry and the Weasley children watch the game.

The campsite away from the stadium contains thousands of tents filled with wizard friends and family, topped by weathervanes, flags, and chimneys. Not surprisingly, the magical accommodations inside the small, unassuming tents defy their exterior size—Arthur Weasley's tent features a lounge area, kitchen, dining nook, and beds that float above the floor. The furniture inside complements the Weasley color scheme of browns and oranges but is scruffy and beat-up. Set designer Stephenie McMillan purchased the pieces at auction houses and used them as is, giving the interior an even more retro look than The Burrow.

Four hundred tents were sewn in Delhi, India, for use on the Beachy Head site, then they were digitally expanded into twenty-five thousand tents spread over a hillside. During the night after the match is completed and both winners and losers are celebrating, Death Eaters attack the wizards in their campsite and burn down the tents. The four hundred practical tents were burned in a practical effect, and then visual effects supervisor Jimmy Mitchell burned down the rest in his computer.

The national teams' Quidditch uniforms were similar to those worn by the Hogwarts players. Souvenirs were sold at the campsite by peddlers topped by bowlers, top hats, or pointy medieval fool's caps. Judging by their fan wear, most of the Weasleys obviously cheer for Ireland, but Ron and Harry wear red and black to root for Bulgaria.

PAGES 32–33: Concept art by Andrew Williamson of the Irish Quidditch World Cup team taking the pitch and an overview of the stadium; TOP AND MIDDLE: Endless tents dot the hills in art by Andrew Williamson; LEFT: Inside Arthur Weasley's tent; OPPOSITE TOP: The Quidditch World Cup competition in action in art by Andrew Williamson; OPPOSITE MIDDLE: Viktor Krum is projected onto the stadium in art also by Andrew Williamson; OPPOSITE BOTTOM: The broom of the Bulgarian Seeker, Viktor Krum.

OCCUPANTS: Quidditch fans, Minister for Magic Cornelius Fudge, Bulgarian and Irish Quidditch teams

FILMING LOCATION: Beachy Head, East Sussex, England

APPEARANCES: *Harry Potter and the Goblet of Fire*

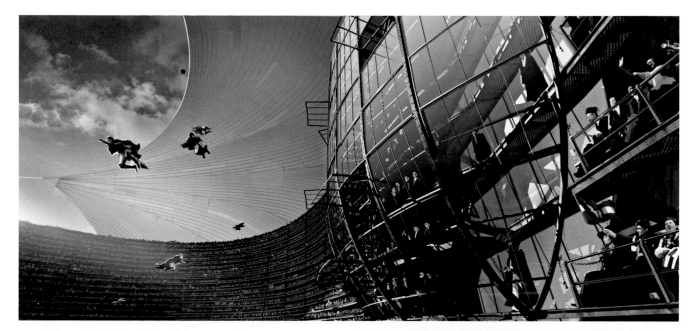

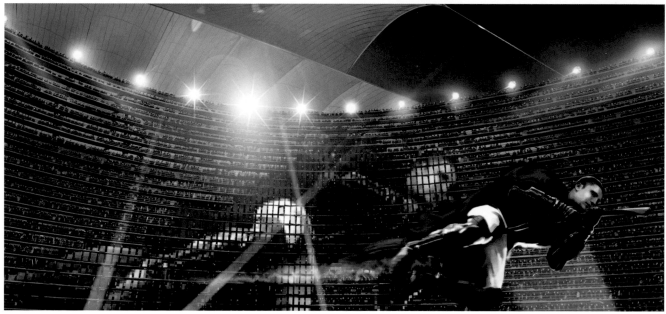

✴ The Bulgarian Seeker ✴

Harry Potter first sees Durmstrang's Triwizard champion at the Quidditch World Cup, as Viktor Krum is the Seeker on the Bulgarian Quidditch team playing in the finals. Visual development artist Adam Brockbank designed Krum's broom for *Goblet of Fire.* "We designed a special broomstick for Krum," explains Brockbank, "although Quidditch moves so quickly, you might not notice it. It was more streamlined than most and quite flat on top with a spine underneath. The top and bottom were in different colors." Krum wears the number seven on his uniform, which had become the established Seeker player number in *Harry Potter and the Prisoner of Azkaban.*

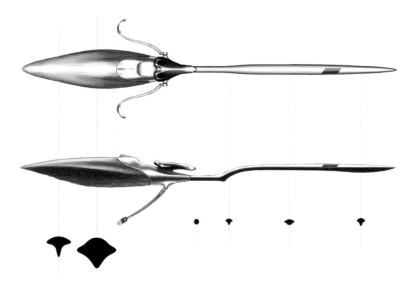

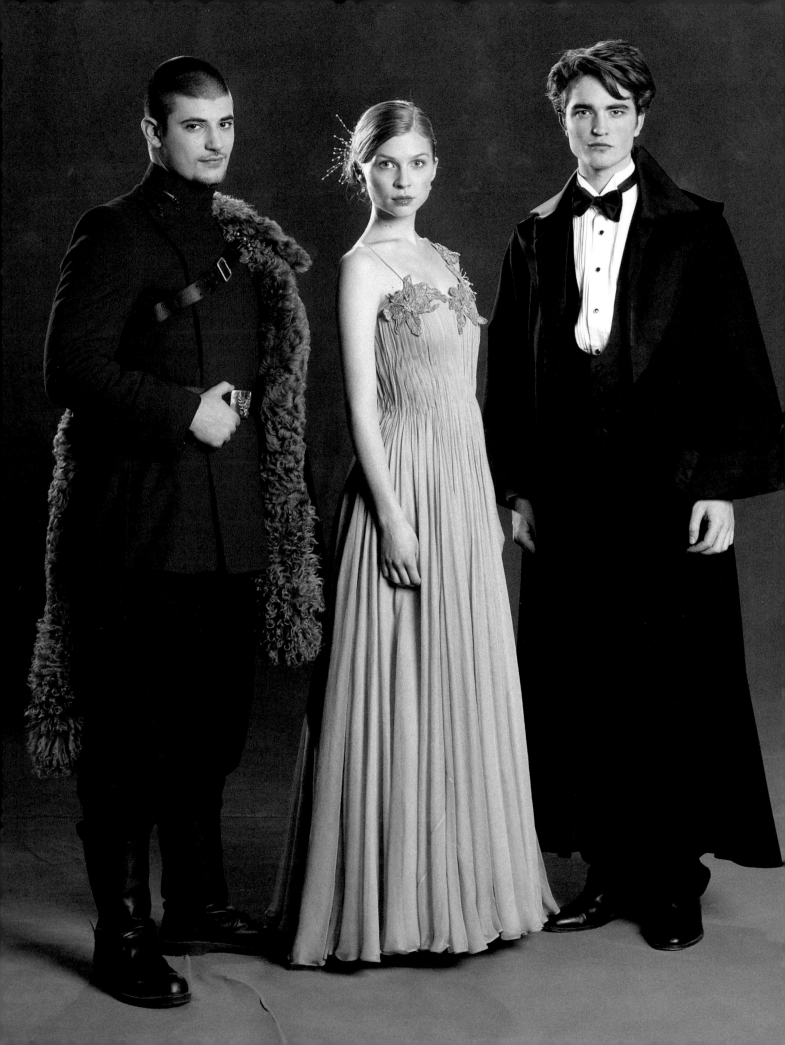

CHAPTER 2
THE TRIWIZARD TOURNAMENT

"Hogwarts has been chosen to host a legendary event: the Triwizard Tournament."

—Albus Dumbledore, *Harry Potter and the Goblet of Fire*

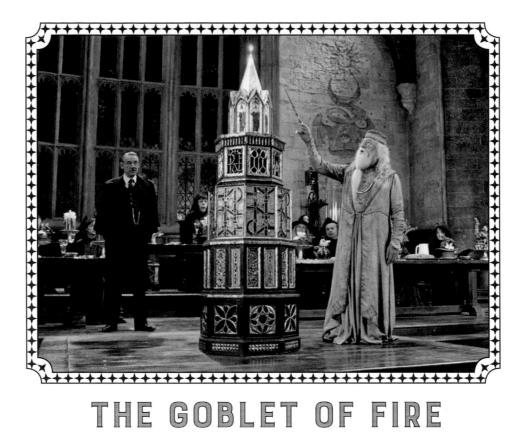

THE GOBLET OF FIRE

"Anyone wishing to submit themselves for the tournament merely write their name upon a piece of parchment and throw it in the flame. . . . Do not do so lightly. If chosen, there's no turning back."

—Albus Dumbledore, *Harry Potter and the Goblet of Fire*

For hundreds of years, the three largest wizarding schools in Europe—Hogwarts School of Witchcraft and Wizardry, Beauxbatons Academy of Magic, and Durmstrang Institute— have held a dangerous competition, the Triwizard Tournament. A champion from each school competes in three tasks that test their courage, cunning, and magical talents. The tournament begins with the reveal of the Goblet of Fire, into which prospective champions from each of the three schools will place their names. The Goblet of Fire is first presented encased in a gilded and bejeweled casket. For the design, production designer Stuart Craig and graphic artist Miraphora Mina blended their research on medieval architecture and the decoration of English and Orthodox Russian churches. "From these inspirations," says Mina, "I had the idea of a stacked construction of arches, one on top of the other. I also wanted it to be heavily jeweled, like church mosaics, as that would be affected by the light around it." Prop maker Pierre Bohanna cast the different sections inscribed with runic or alchemic symbols, and they were variously inlaid with gold leaf and painted jewels, or other light-catching materials. "It's almost like a religious reliquary," says Craig, "but of a type that's never been seen before." The casket is visible for only a short time, and then "melts" away to reveal the goblet. Mina remembers

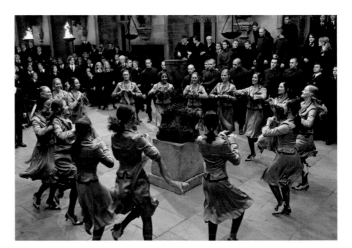

PAGE 36: Three Triwizard champions dressed for the Yule Ball: (*left to right*) Viktor Krum (Stanislav Ianevski), Fleur Delacour (Clémence Poésy), and Cedric Diggory (Robert Pattinson); TOP: Dumbledore (Michael Gambon) reveals the Goblet of Fire as Barty Crouch, Sr. (Roger Lloyd-Pack) looks on; ABOVE: Beauxbatons students surround the Goblet; OPPOSITE CENTER LEFT AND BOTTOM LEFT: The Triwizard champions are selected; OPPOSITE RIGHT: The organic, ancient Goblet of Fire.

being asked if that could be a practical effect, but it was quickly decided that it was easier done digitally. "But the casket is a real physical object, no doubt," Mina proclaims. "I had to carry it into the Great Hall!"

Craig's original intention was for the cup to be small, metal, and encrusted with tiny jewels. But after their research, the Goblet of Fire became "basically a huge Gothic cup decorated with a Gothic motif that's been created from wood," he explains. "We found the best bit of timber we possibly could, with burrs and twists and knots and splits in it. So this creates a quality that it's incredibly ancient, but at the same time organic." Pierre Bohanna and his team sculpted the five-foot-tall goblet out of an English elm tree trunk, with the addition of some plastic castings. Mina's idea behind the goblet was that because the lower half is wood, which creeps up to meet the curve of the goblet's base, one couldn't be sure whether it was still growing. "The impression to me is that it's half complete," says Craig. "Half architectural and half natural, as if the carving of it hasn't been finished. And I think it's as great in silhouette as it's great in detail when you examine it closely."

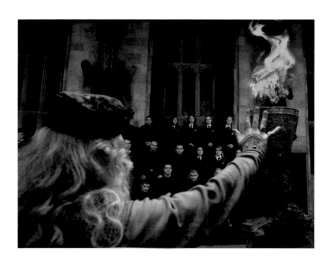

THE TRIWIZARD CUP

"Only one will hoist this chalice of champions, this vessel of victory, the Triwizard Cup!"

—Albus Dumbledore, *Harry Potter and the Goblet of Fire*

An ancient artifact, the Triwizard Cup and its design echo the organic quality of the Goblet of Fire, while exhibiting enthralling craftsmanship at the same time. Miraphora Mina's research revealed a precedent between Muggle and magical design, noting that a dragon motif was quite prevalent on the relics and chalices she referenced. The "tri" in Triwizard is evident in its three dragons, which represent the three schools that participate, and three crystal panels that form the trophy. Given the task of realizing the Cup in physical form, prop maker Pierre Bohanna felt that Mina's concept easily gave him a strong impression of what the metalwork would be. "We didn't want it to be silver," he explains. "We didn't want it to be too finished. We wanted it to look like it was a weighty casting, and a very old piece. You can't get that with a silver finish." Bohanna discovered a process combining alloys that would create a finish that was almost lead-like, with a desired blue-gray coloring. Each piece of the cup had a mold that allowed it to be created in different materials for its different uses. Several were made in latex and rubber, because they had to go flying when the cup is used as a Portkey. Others were cast in metal or in resin. The three panels etched with the broken-up word TRI-WIZ-ARD echo the Goblet of Fire in that the relic is also unfinished. "There are stylized flames and fernlike details inside the crystal that I consider are growing all the time, so it's as though it's something living," Mina says. Bohanna used a blend of different chemicals that counter-reacted to each other, causing a fractured and cracked appearance. But his special ingredient for creating the effect was . . . "Cling Wrap," he admits. "Tiny confetti-size chips of plastic Cling Wrap were thrown into the process, which caused the chemicals to pull away from one another." The idea came to him when he was analyzing natural materials that had folds and cracks. "Nature always has the answer," he affirms.

RIGHT: A prop reference shot of the objective of the Triwizard Tournament: the Triwizard Cup; OPPOSITE TOP: The Triwizard Cup is displayed for the three participating schools as Albus Dumbledore (Michael Gambon) reminds them of the seriousness of entering the contest; OPPOSITE BOTTOM: Cedric Diggory (Robert Pattinson) and Harry Potter (Daniel Radcliffe) reach for the Cup together after completing the third task, not knowing it is a Portkey to Voldemort.

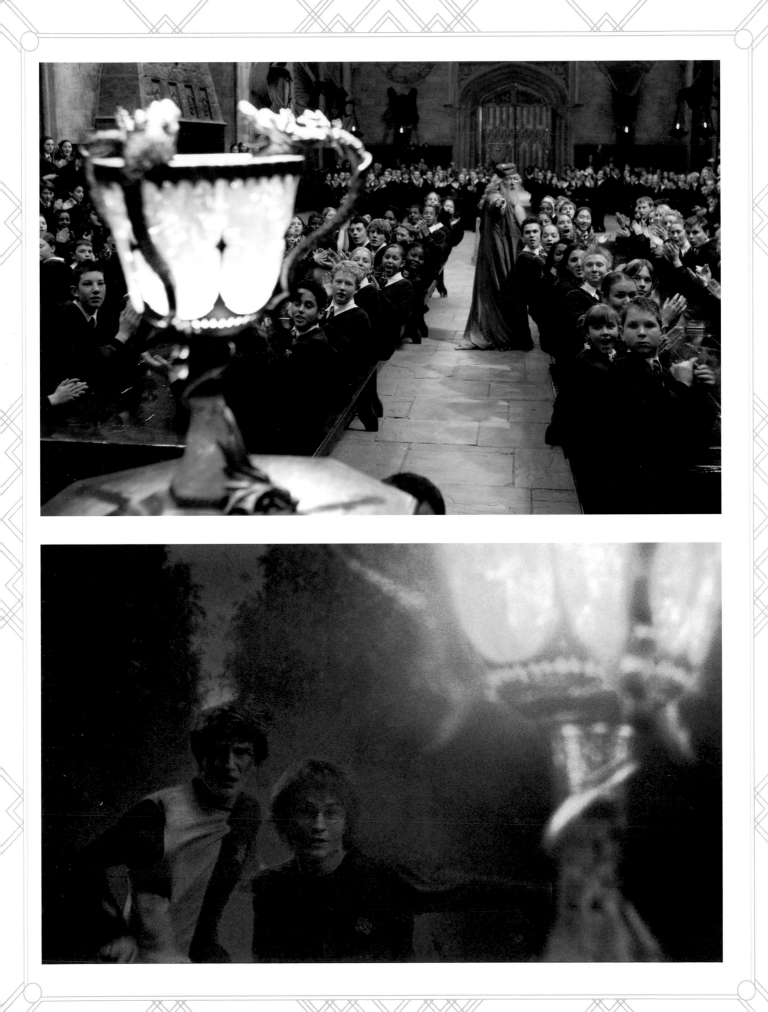

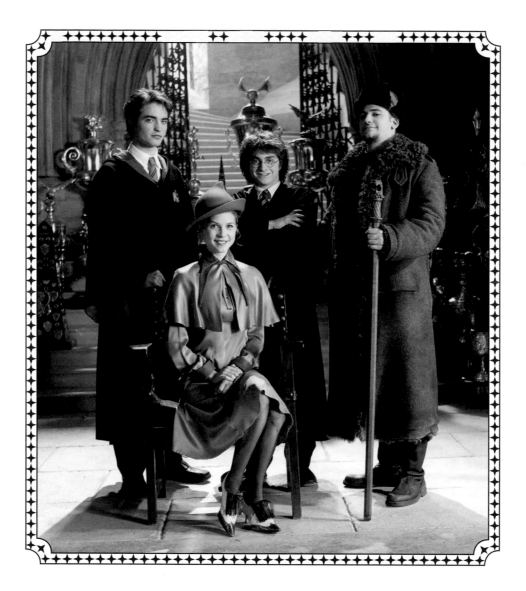

THE TRIWIZARD CHAMPIONS

Normally, the Triwizard Tournament has three champions, one from each participating school, but for the competition that comes to Hogwarts this year "there's a huge uproar," says Daniel Radcliffe, "because not only do they have the three names: Cedric Diggory, Fleur Delacour, and Viktor Krum, but Harry's name comes out as well."

French actress Clémence Poésy describes her character, the Beauxbatons champion Fleur Delacour, as "graceful and quite serious and very Miss Perfect all the time." She saw Fleur as similar to "the girls I used to hate in high school," Poésy says, laughing. "The ones who do everything perfectly and don't look at anyone else in the room. She embodies all the French clichés. She's *not* a cliché, but she is what you'd think a French woman would be."

Bulgarian actor Stanislav Ianevski thought of his character Viktor Krum as "a manly boy; more a physical being than talkative." Ianevski developed the Durmstrang student through his physical actions and, in spite of their warmth, through his costumes. "I really enjoyed filming Viktor Krum's entrance into the Great Hall," he explains. "As soon as I put that big fur coat on, I became more powerful in terms of the character."

The *official* Hogwarts champion is Cedric Diggory from Hufflepuff house, played by Robert Pattinson. "Cedric is a pretty nice guy," says Pattinson. "He's seventeen, a prefect, and plays fair and sticks to the rules. Everyone is rooting for him at the beginning, but in a way, he takes Harry under his wing, and although competitive, gets his priorities right in the end."

Being chosen by the Goblet of Fire is anything but an honor for the second Hogwarts champion: Harry Potter. "He's back in the limelight again," explains Daniel Radcliffe. "When his name comes out of the Goblet of Fire, he instantly knows that everyone suspects him of some kind of foul play. And because he knows he didn't put his own name in the Goblet, someone else must have done it, and that could get him killed!"

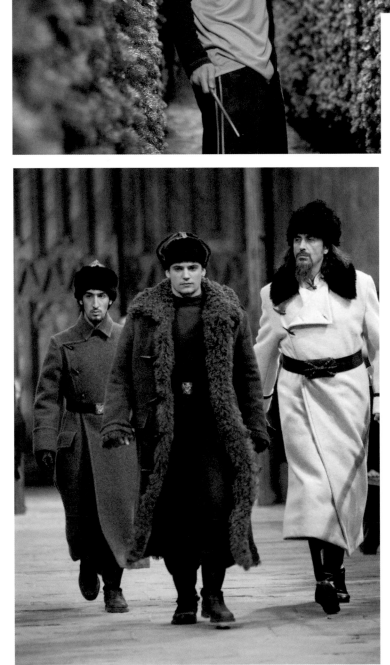

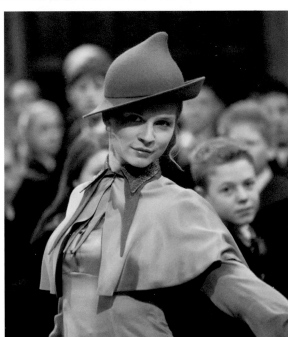

OPPOSITE TOP: The four Triwizard champions pose for a publicity photo: (*left to right*) Cedric Diggory (Robert Pattinson), Fleur Delacour (Clémence Poésy), Harry Potter (Daniel Radcliffe), and Viktor Krum (Stanislav Ianevski); TOP LEFT: Hogwarts champion Cedric Diggory in the maze of the third task; ABOVE: Beauxbatons champion Fleur Delacour; BOTTOM LEFT: The Durmstrang contingent arrives with (*left to right*) student aide (Tolga Safer), Durmstrang champion Viktor Krum (Stanislav Ianevski), and Headmaster Igor Karkaroff (Predrag Bjelac).

SCHOOL TROPHIES

"What a charismatic quartet."
—Rita Skeeter, *Harry Potter and the Goblet of Fire*

The Trophy Room at Hogwarts is seen briefly in *Harry Potter and the Goblet of Fire*; it's where the Triwizard Tournament champions gather after they are announced in the Great Hall. Filled with hundreds of trophies, the room might seem familiar: In *Harry Potter and the Order of the Phoenix*, it was transformed into the Room of Requirement, and in *Harry Potter and the Half-Blood Prince*, it was used as Horace Slughorn's office. The props department referred to the books for inspiration as they created originals and altered purchased trophies in a wizardly fashion. In addition to Quidditch trophies, there were Medals for Magical Merit, Awards for Special Services to Hogwarts, and other plaques and shields for Transfiguration, Chess, Potions, Bravery, and Effort. The prop makers inscribed these with names from the books as well as those of the film's crew members.

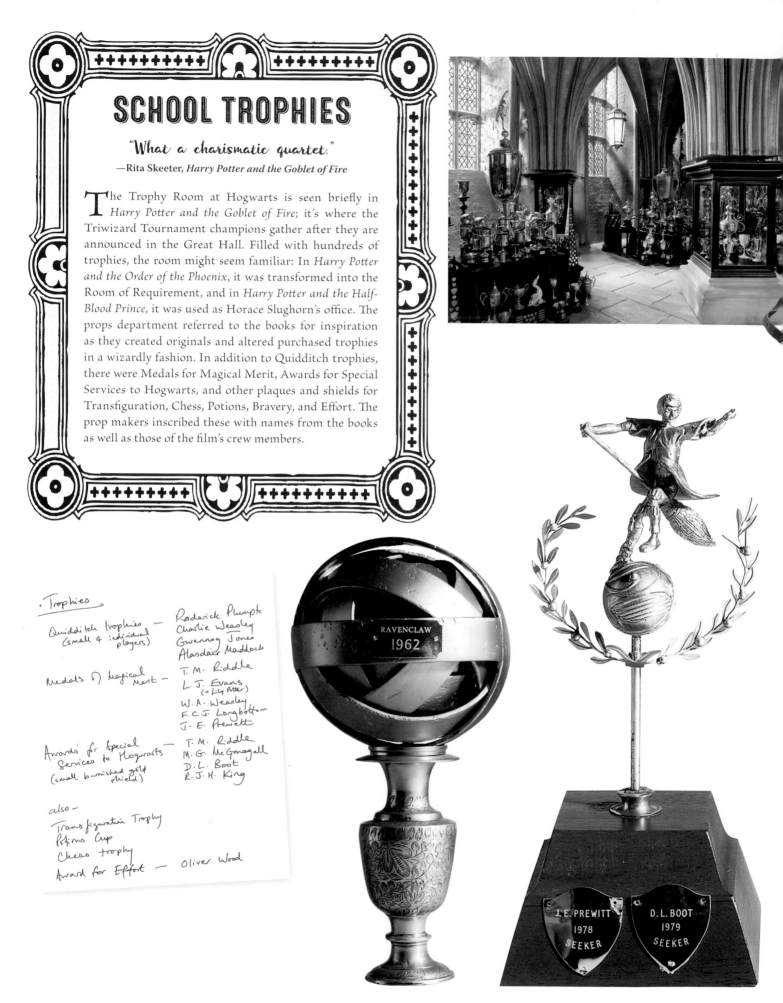

. Trophies

Quidditch trophies — Roderick Plumpton
(small 4 individual Charlie Weasley
players) Gwenog Jones
Alasdair Maddock

Medals of Magical — T. M. Riddle
Merit L. J. Evans
(= Lily Potter)
W. A. Weasley
F. C. J. Longbottom
J. E. Prewett

Awards for Special — T. M. Riddle
Services to Hogwarts M. G. McGonagall
(small burnished gold D. L. Boot
shield) R. J. H. King

also —
Transfiguration Trophy
Potions Cup
Chess trophy
Award for Effort — Oliver Wood

RAVENCLAW
1962

J. E. PREWITT
1978
SEEKER

D. L. BOOT
1979
SEEKER

QUICK-QUOTES QUILL

"Don't mind if I use a Quick-Quotes Quill, do you?"

—Rita Skeeter, *Harry Potter and the Goblet of Fire*

The questionable investigative tactics of Rita Skeeter, reporter for the *Daily Prophet*, are very much in view when she interviews Harry Potter, the youngest Triwizard Tournament champion, in *Harry Potter and the Goblet of Fire*. Skeeter uses a Quick-Quotes Quill, which rewrites a subject's responses into sensationalist journalism. The animated nib is connected to an acid green–dyed feather that complements her outfit.

OPPOSITE: (*clockwise from top left*) A production reference shot of the trophy room; a trophy awarded to two Quidditch Seekers; and a victory trophy for Ravenclaw house; LEFT: The camera used by the *Daily Prophet* photographer who accompanies Rita Skeeter during the first task of the Triwizard Tournament; BELOW: The Quick-Quotes Quill with Rita Skeeter's written notes; BELOW LEFT: Miranda Richardson (Rita Skeeter) on set inside of the champions' tent in *Harry Potter and the Goblet of Fire*.

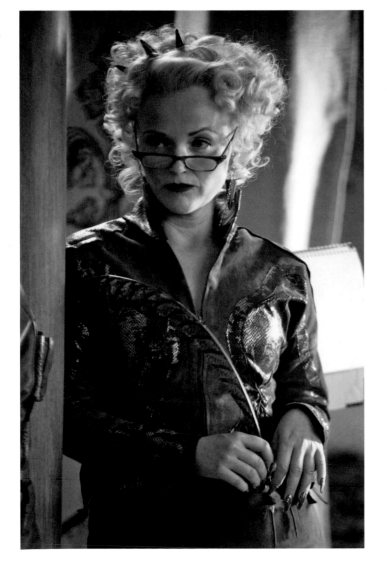

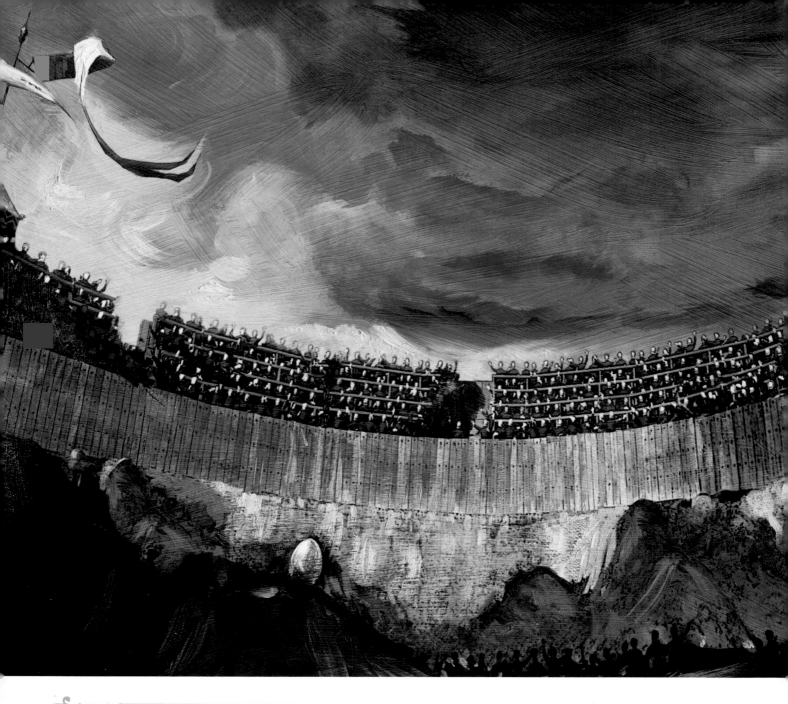

TRIWIZARD TOURNAMENT ARENAS
★ Triwizard Tournament First Task: Dragon Arena ★

OCCUPANTS: The Triwizard Tournament champions, Dragons

FILMING LOCATIONS: Steall Falls, Glencoe, Scotland; Black Rock Gorge, Evanton, Scotland

APPEARANCE: *Harry Potter and the Goblet of Fire*

Location shoots in Scotland provided the backdrop for Harry Potter's encounter with the Hungarian Horntail dragon during the first task of the Triwizard Tournament in *Harry Potter and the Goblet of Fire*. As is his practice, Stuart Craig saw the construction of the dragon arena as a sculptural form. "It seemed that the starkest, rawest, most interesting thing we could do would be to set it in a bare, rocky pit," he explains. "So we scouted rock quarries and places with very sharp, jagged rocks." The quarry bottom was built in the studio and above that, Craig placed the spectators on bleachers at a very steep angle looking down on the action. "There's a massive wooden fence around the top of the arena and then the bleachers are behind that. So it has the kind of concentration and intimacy that's equivalent to a bull ring. Then we've set all that on a mountaintop in Glen Inverness in Scotland. If you didn't see it with the backdrop, I think it would appear quite ordinary. You composite it with Glen Inverness, and it's stunning."

"Dragons? That's the first task? You're Joking."

—**Harry Potter**, *Harry Potter and the Goblet of Fire*

THESE PAGES: (*clockwise from top left*) Art by Emma Vane shows the view from the floor of the Triwizard Tournament dragon arena; two locations in the Highlands of Scotland were used to shoot back plates for the task; a still shows Harry taking cover in *Harry Potter and the Goblet of Fire*.

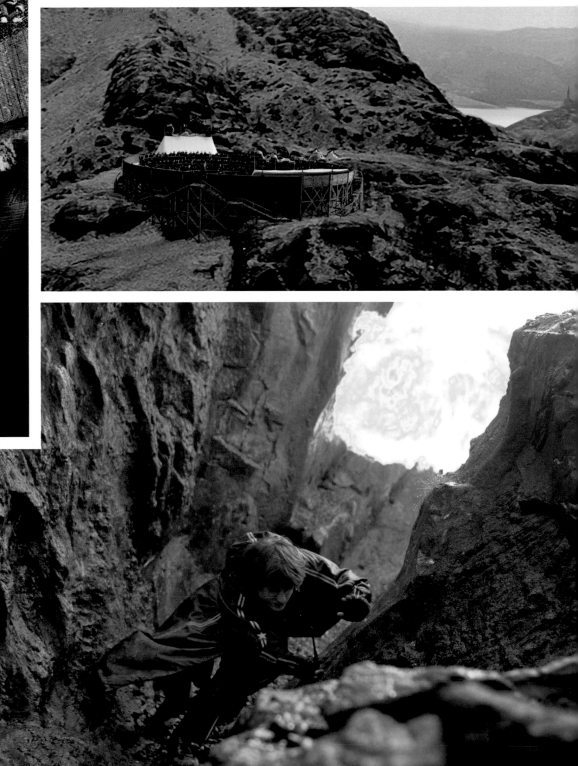

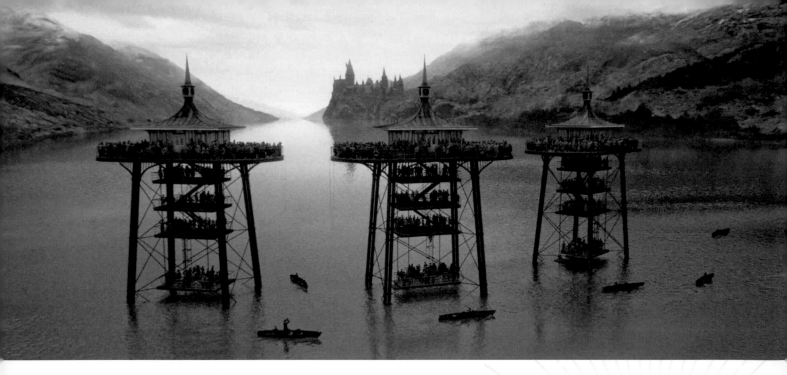

✶ Triwizard Tournament Second Task: The Lake ✶

The lake beside Hogwarts castle is as much a part of the school's silhouette as its towers and spires. Throughout the films, various locations have been used to portray the lake, including Virginia Water Lake in Surrey, England. This is the lake over which Harry takes flight on Buckbeak and later encounters Dementors, in *Harry Potter and the Prisoner of Azkaban*; it was also filmed for the lakeside scenes in *Harry Potter and the Goblet of Fire*. Other locations used, especially in background shots, include Loch Shiel, Loch Eilt, and Loch Arkaig in Lochaber, Scotland.

The second task of the Triwizard Tournament in *Goblet of Fire* takes place below the lake, and this was achieved by merging studio and digital shots. However, the stands above the waterline for spectators were an ingenious choice by designer Stuart Craig. He wanted to place them in a position that would add the proper amount of drama for those waiting for the champions to reappear from the lake bottom. "Rather than just have people sitting on rocks on the perimeter of the lake, not able to see very much, it occurred to me to have these rather dramatic viewing stands out in the middle of the lake." He based his design for these platforms on Victorian pier structures. "Not just stationary seaside piers," he explains, "but there were these structures on great long legs that actually ran on rails under the water. So these became mobile viewing stands." Viewing scopes to watch the champions underwater were also conceived but ultimately not created for the film.

PAGES 48–49: Harry confronts a Hungarian Horntail in the first task of the Triwizard Tournament in artwork by Paul Catling for *Harry Potter and the Goblet of Fire*; TOP: A composited image of the lake used in *Harry Potter and the Goblet of Fire*; OPPOSITE TOP AND BOTTOM: Concept art shows Harry in the lake (*bottom*) and, in art by Dermot Power, pursued by Grindylows (*top*).

> "Myrtle, there aren't merpeople in the Black Lake, are there?"
>
> —**Harry Potter**, *Harry Potter and the Goblet of Fire*

OCCUPANTS: The Triwizard Tournament champions, merpeople, Grindylows

FILMING LOCATIONS: Virginia Water Lake, Surrey, England; Loch Shiel, Loch Eilt, and Loch Arkaig, Lochaber, Scotland

APPEARANCES: *Harry Potter and the Sorcerer's Stone, Harry Potter and the Chamber of Secrets, Harry Potter and the Prisoner of Azkaban, Harry Potter and the Goblet of Fire, Harry Potter and the Order of the Phoenix, Harry Potter and the Half-Blood Prince, Harry Potter and the Deathly Hallows – Part 2*

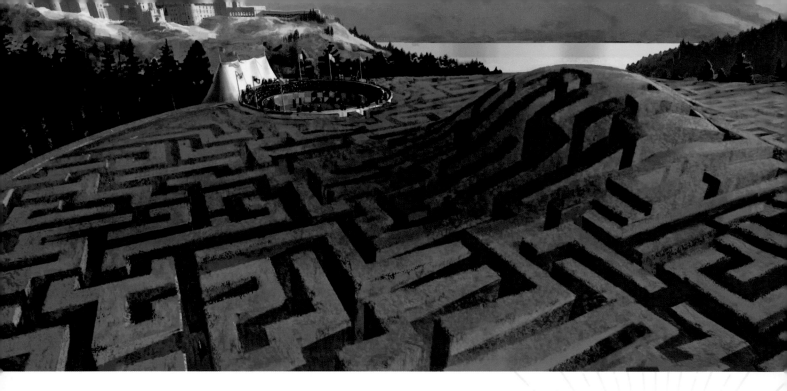

✶ Triwizard Tournament Third Task: The Maze ✶

The final task for the champions in the Triwizard Tournament in *Goblet of Fire* is to negotiate a maze in order to reach the Triwizard Cup. "We all think we know what a maze should be," says production designer Stuart Craig with a smile, "but it seems nothing in Hogwarts is ever what we think it is." He designed the maze to be taller and bigger than anything that could possibly be created in real life. The maze's channels were set with the proportion of being five feet wide and twenty-five feet high. "It's misty and altogether completely disorienting and disturbing," Craig says. "Things move and attack, but all of that is, as you know, just the lead-up to the graveyard that is the final confrontation." Craig "set" the maze near Fort William in the Highlands near Glen Nevis, Scotland. "We were standing in that spectacular valley, thinking about how much area the maze should occupy. Well, the whole point of the thing is to find the center, which should not be easy. Then let's make it as difficult as it possibly could be, so the whole thing became two miles long and half a mile wide and filled the valley. Exaggeration," he asserts, "is one of the best weapons in our armory."

Special effects supervisor John Richardson was tasked with creating the moving maze. Richardson's crew built a forty-foot-long section of maze with walls that moved independently, rippling and tilting, coming together and moving apart. "It had to move as if it was chasing them, as if it was going to crush them, but, of course, we installed a fail-safe mechanism in it," Craig says. "The walls were built out of heavy steel, so that they were strong enough to support themselves, and they moved via a system of complex hydraulics that allowed the operators full control. The maze was enhanced with digital effects, but it also used practical effects, such as a dry ice mist that drenched the whole set. Robert Pattinson (Cedric Diggory) found the authenticity of the effects helpful when acting. He says, "There [were] real explosions going off, and the whole maze [was] moving, so you're running around, actually fearing for your life!"

"You see, people change in the maze."

—**Professor Dumbledore,** *Harry Potter and the Goblet of Fire*

OCCUPANTS: The Triwizard Tournament champions

APPEARANCE: *Harry Potter and the Goblet of Fire*

THESE PAGES: Film stills and concept art show Harry Potter in the maze.

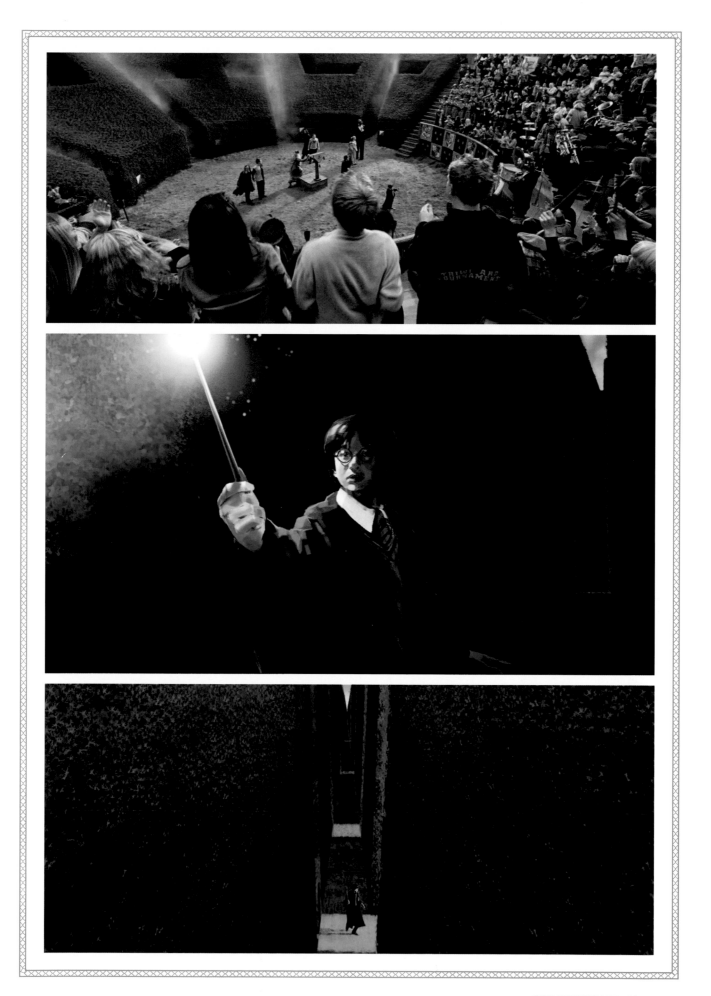

THE GOLDEN EGG

*"Come seek us where our voices sound, we cannot sing above the ground.
An hour long you'll have to look, to recover what we took."*

—The merpeople's clue for the second task, *Harry Potter and the Goblet of Fire*

The first task of the Triwizard Tournament is to capture a golden egg being protected by a dragon. Once opened, the egg will reveal a clue to the second task. Designer Miraphora Mina first decided that the outside decoration of the egg would be quite formal: "It has an etching of a city—not a mythical, magical city, but maybe a historical place somewhere." Mina liked the idea of the prop's exterior appearing to be enameled (although it actually wasn't), and having alchemic symbols etched into it. In the book *Harry Potter and the Goblet of Fire*, the interior of the egg is described as a song. "So it needed to be something ethereal," says Mina. "Something where you couldn't quite work out whether the song is its content or if it's on the surface. So we imagined a crystal structure where things were possibly going on inside, but you couldn't easily work out what they were."

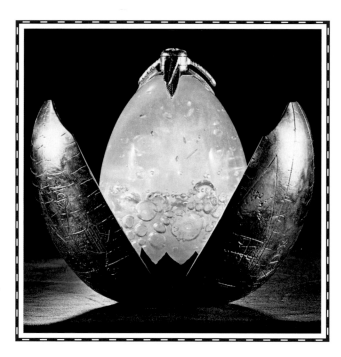

Another theme that Mina tried to incorporate in her designs for the films was the idea of discovery. For the golden egg, one of her areas of research was Fabergé eggs, created for the Imperial Russian family from the 1880s to the first decades of the twentieth century. These gold and silver eggs would open to reveal scenes created with jewels and enamel. "I think, to discover something, you need to work for it," Mina says. The mechanism to open it was a practical effect. "It's quite simple, really," she concedes. "I wanted something that would spring open automatically, as if you had the right code." Mina designed the device as a little owl's head that sits atop three wings, the number of which ties into the Triwizard Tournament. "And it's always interesting to have an uneven number," she adds, "so I knew it would break into three segments. Not like you were cracking an egg in half!" The device was hinged inside with a cantilevered arm so that the top layer of it would turn, lift, and release the three metal wings. The exterior of the egg was gold-plated. "We used gold-plating quite a lot," says prop maker Pierre Bohanna, "because this prop and others have the reputation of being special. It's not cheap, but it's not *that*

expensive, and it works beautifully on film. It's got a quality that reflects light that you can't replicate with paint."

Once the top is turned, "it's as if you go down to another layer," says Mina. "I wanted there to be a contrast between the outer shell and the inside. It looks as though it's actually alive inside in a way." The bubbles within the egg are "not really bubbles in the sense of what bubbles are," Bohanna adds. The bubbles were created using small acrylic balls that became suspended in the resin solution used to make the core. "When any substance, like the resin we used, goes from a liquid state to a hard one," Bohanna continues, "it tends to shrink or expand. This particular product didn't stick to the plastic balls; it shrank away from them, and we got an incredibly convincing bubble effect." During the same process, pearlescent pigments were added that, in their own conversion from liquid to solid, "swirled" within the mix. "Our chief molder, Adrian Getley, was able to introduce the pigment at just the right time to catch it and allow it to create movement that looked like eddies and currents, and then stop before it traveled too deep as it set."

The egg was completely waterproof as it would need to be submerged during the many takes for the scene. It also weighed over ten pounds. "It would sink right to the bottom if you gave it half a chance," Bohanna admits. In order to keep the egg from tipping over when it was opened underwater, Daniel Radcliffe (Harry Potter) wore an invisible plastic clip around one hand that connected to a clip on the egg. This freed his fingers so that he could handle it without having to use both his hands.

OPPOSITE: Designer Miraphora Mina's concept art for *Harry Potter and the Goblet of Fire* displays an aerial view of the opened golden egg; ABOVE: A reference photo of the golden egg reveals the amazing bubbling effect created by the prop makers by suspending small acrylic spheres and pearlescent pigments within the resin mold.

LIFECASTS

*"Last night something was stolen from each of our champions. A treasure of sorts.
These four treasures, one for each champion, now lie on the bottom of the Black Lake."*

—Albus Dumbledore, *Harry Potter and the Goblet of Fire*

The second task of the Triwizard Tournament took place under the murky waters of the Black Lake, where the champions needed to rescue people dear to them who had been charmed into an enchanted sleep and were floating in the merpeople's village. "There was no way we were going to tie an actor to the bottom of a tank for three weeks of filming!" exclaims Nick Dudman, special makeup effects artist for the Harry Potter film series. And so lifecasts of the four actors were taken and used to create their submerged doubles.

Creating a lifecast of an actor for a movie is a technique that harkens back to the earliest days of filmmaking, and it is more commonplace today than it's ever been. Lifecasts are made when prosthetics need to be fashioned for complicated makeups or to create a face mask for the actor's stunt double. Today's needs include requiring a lifecast for animatronic or computer effects. "The reason for that is actually really simple," explains Dudman. "Quite often, we need to cyberscan someone, and when you're cyberscanning somebody with a laser, it's inevitable they'll move. They can't keep that still. If you scan and have a cup made, the copy is perfect. If you scan somebody's head, when you get it back from the scanning company, it's blurred. The detail is smudged on it, and it's because in the time the camera takes to go around or to slide down or whatever it's doing, there are tiny little movements. However, if we take a lifecast of somebody and scan that, it's absolutely nonmoving. So the quality of the scan the CG people obtain is ten times better."

The lifecasting process has evolved over the years, but the basic material—dental alginate—is still the main ingredient. First, a plastic cap is used to protect the actor's hair. Then the alginate, in powder form, is mixed with water. This turns into a rubbery consistency after three minutes. "Before it sets completely," Dudman explains, "you put it all over the whole head and shoulders, or the whole body, if that's what you need." Breathing holes are created as the alginate solidifies. Then the alginate is covered with a layer of plaster bandages that keep the material in place until it dries. "When it's finished setting," he continues, "you cut it apart at a predetermined seam, take the actor out, reassemble the pieces, and fill it with plaster to make a perfect double. It's a very old-fashioned method, but it's still unsurpassed because plaster is the best material for giving you the data you need. It gives you all the skin texture down to a ridiculous level of detail—every single freckle, pore, and line." The plaster mold can then be used to create a double in whatever casting material is desired. Individual eyelashes and eyebrow hairs are punched in, as well as a full head of hair, and then the lifecast is painted with an amazing amount of detail. "If done properly," Dudman concludes, "they are incredibly accurate representations."

Lifecasts were made of the key cast members from the first film in the series, but what was unique about the Harry Potter films was that they needed to be redone at the start of *every* film, as the young actors were (literally) growing up. And lifecasts were an absolute necessity to tell the story. When the victims of the Basilisk released from the chamber below Hogwarts in *Harry Potter and the Chamber of Secrets* are rendered immobile by the gaze of the serpent, they are Petrified, essentially turned to stone, until an antidote can revive them. It would be unreasonable to expect the actors playing Colin Creevey, Justin Finch-Fletchley, Nearly Headless Nick, and Hermione Granger to lie or stand motionless over and over again during filming, and so lifecasts saved the day. (The petrified Mrs. Norris was an animatronic version of the cat.)

The same need arrived in the fourth film for the underwater scenes, but the doubles of Ron Weasley, Hermione Granger, Cho Chang, and Fleur Delacour's sister Gabrielle, needed to show some movement. Animatronic dummies were made from lifecasts of the actors with a flotation tank inserted into them. The tank could have air pumped in and out in order to create the illusion of floating, and could cause bubbles to emerge from their mouths. Additionally, water was pumped into the bodies from outside the holding tank. This would transfer the water from one place to another within the figure; but because water shifts slowly, it created a gentle and natural movement.

Lifecasts were also used for characters who needed to be suspended in air: Katie Bell in *Harry Potter and the Half-Blood Prince*

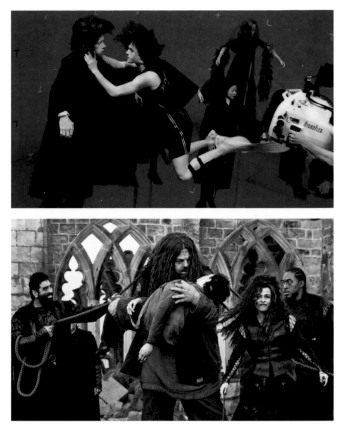

and Charity Burbage in *Harry Potter and the Deathly Hallows – Part 1*. Visual effects producer Emma Norton echoes Nick Dudman's sentiments: "You can't hang an actress upside down for ten hours of filming every day!" These dummies were mechanized so that the bodies could writhe and their faces could reflect their pain. Two versions of a lifecast of Michael Gambon were created for *Harry Potter and the Half-Blood Prince*. It was intended that, after Dumbledore's fall from the tower, Hagrid would carry the deceased wizard across the Hogwarts grounds. However, because Hagrid is a half-giant, the Dumbledore lifecast needed to be produced a second time in a reduced version to keep the characters' scale in mind, and in the lightest weight possible, as Martin Bayfield, who played the full-scale Hagrid in long shots, was already carrying many pounds of costume and animatronics. Eventually, it was decided not to shoot this particular scene, but the knowledge gained from the task informed Dudman's crew when they created a supposedly deceased and definitely smaller scale Harry Potter to be carried by Hagrid in *Harry Potter and the Deathly Hallows – Part 2*.

OPPOSITE: Lifecasts in their early stages for *Harry Potter and the Half-Blood Prince*. Once the alginate is removed, the molds are covered with a fiberglass fabric for stability before being filled with plaster; LEFT: The lifecast of Hermione Granger for *Harry Potter and the Goblet of Fire* was fitted with a flotation tank inside that created the illusion of her floating in water and emitting air bubbles from her mouth; TOP: The second task required four students to be suspended underwater for many days of shooting: not something you would ask actors to do! ABOVE: Hagrid carries a supposedly dead Harry Potter into the Hogwarts courtyard in *Harry Potter and the Deathly Hallows – Part 2*.

MADAME MAXIME

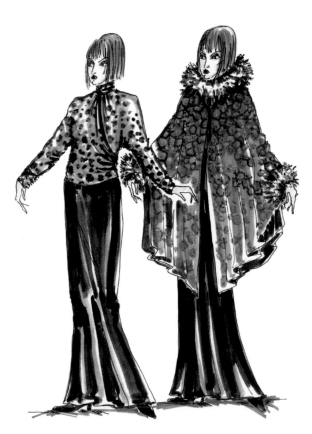

When asked to describe her character, the Beauxbatons Headmistress Madame Olympe Maxime, Frances de la Tour states: "She's a teacher who loves her girls and dresses them all beautifully. And she just happens to be big." After a pause, de la Tour continues, "She's in serious denial about being big."

When Jany Temime met with de la Tour, the actress reiterated the character's philosophy of "I'm not big" and even asked if the character could appear thin. "But I told her, 'No, you are a giant, you are big. A big presence, but an elegant one. You will never be a tiny little thing. So think formidable,' says Temime. "She is a woman who wants to be seen." Madame Maxime's elegant clothing inspired Eithne Fennell to give the Headmistress chic hair styles to complement the outfits. "We thought a simple bob would do, but to give her a bit more flair, we'd streak her hair with different colors to go with her outfits."

To play Madame Maxime at her most gigantic, seven-foot-tall basketball player and film actor Ian Whyte was scaled up to eight foot four by wearing stilts with high heels. So in addition to the problems inherent in scaling up clothing prints, Temime needed to ensure that Madame Maxime's outfits were floor length to cover the stilts, and had long sleeves in order to seamlessly disguise the transitions to her double's fake hands. To camouflage the attachment point for Maxime's silicon animatronic head, Temime used faux fur collars and cuffs, feathered neck pieces, and even large ruffs. In addition to learning to walk on the stilts, Whyte needed to learn to waltz with Martin Bayfield, Hagrid's double, for the Yule Ball.

APPEARANCES: *Harry Potter and the Goblet of Fire, Harry Potter and the Deathly Hallows – Part 1*

OCCUPATION: Beauxbatons Headmistress

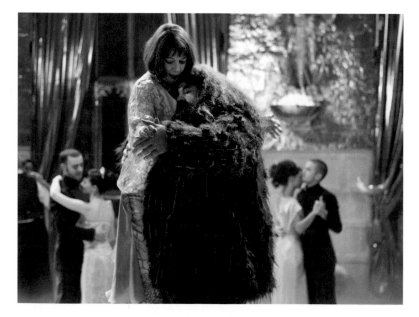

INSET: Frances de la Tour as Madame Maxime; LEFT: Madame Maxime and Hagrid dance at the Yule Ball in *Harry Potter and the Goblet of Fire*; ABOVE AND OPPOSITE LEFT AND CENTER: An assortment of suits and separates, all sketched by Mauricio Carneiro; OPPOSITE TOP RIGHT: The Beauxbatons girls' entrance in *Goblet of Fire*; OPPOSITE RIGHT: Madame Maxime's outfits required high collars.

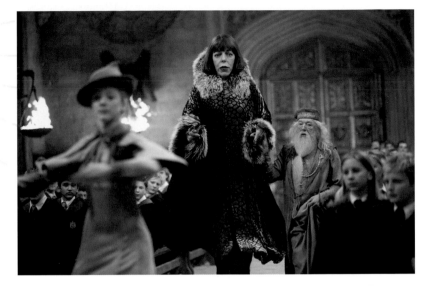

*"Blimey, that's
one big woman."*

—**Seamus Finnigan,** *Harry Potter
and the Goblet of Fire*

Madame Maxime's animatronic head was equipped with a performance control device that activated the mouth's movement as Whyte delivered dialogue from inside. This helped to cue the other actors. The other facial expressions and eye movements were controlled by Nick Dudman's crew. "But there are always shots where you must have the actor's performance," Dudman explains, "where you want to start close on her face, pull out, and reveal her size. Then you'd blue screen her." In other instances, Dudman used inventive ways to create the illusion of height when shooting close-ups of de la Tour. "We used smaller sets, cheated angles, and sometimes we just put her on a pile of boards that raised her up. When you see the film, you should think, 'My God, that woman is tall.' And if we can achieve that, then it's a job well done."

DURMSTRANG
IGOR KARKAROFF

Though not as tall as his counterpart at Beauxbatons, Igor Karkaroff, the Headmaster of Durmstrang Institute, who appears in *Harry Potter and the Goblet of Fire*, is formidable in his own way. "I think he acts very dramatically and even arrogantly," says Serbian actor Predrag Bjelac, "but it's because of his past. He's trying to appear to be what he was before the trials, someone on top of things, but, really, he knows he's not on top anymore." Karkaroff's past is that of a convicted Death Eater who gives up Barty Crouch Jr. in exchange for freedom. Seen in a Pensieve flashback, Bjelac is dressed in the rags of an Azkaban prisoner. His look was adjusted with fake colored teeth—"Of course they're not mine!" Bjelac declares—and a beard he grew for the part was given extensions, "but my hair is always like that," he laughs. The actor admits to feeling claustrophobic while encased in the Iron Maiden–like cage he sat in for a week of filming, but he used the fear to enhance his performance.

APPEARANCE: *Harry Potter and the Goblet of Fire*

OCCUPATION: Head of Durmstrang Institute

MEMBER OF: Death Eaters

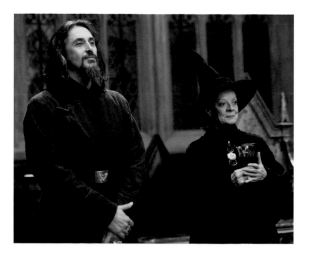

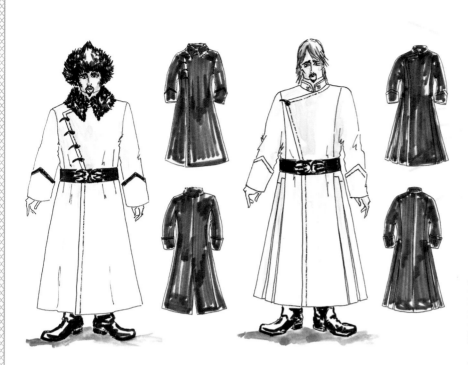

"It's a sign, Severus.
You know it is."

—Igor Karkaroff, *Harry Potter
and the Goblet of Fire*

OPPOSITE INSET AND OPPOSITE RIGHT: Predrag Bjelac as Durmstrang Headmaster Igor Karkaroff; OPPOSITE BOTTOM LEFT: Karkaroff and Professor McGonagall at the Triwizard Tournament opening banquet in *Harry Potter and the Goblet of Fire*; LEFT: Sketches by Mauricio Carneiro of Jany Temime's designs for Karkaroff's coat; BELOW: Igor Karkaroff and his aide (Tolga Safer) arrive in the Great Hall.

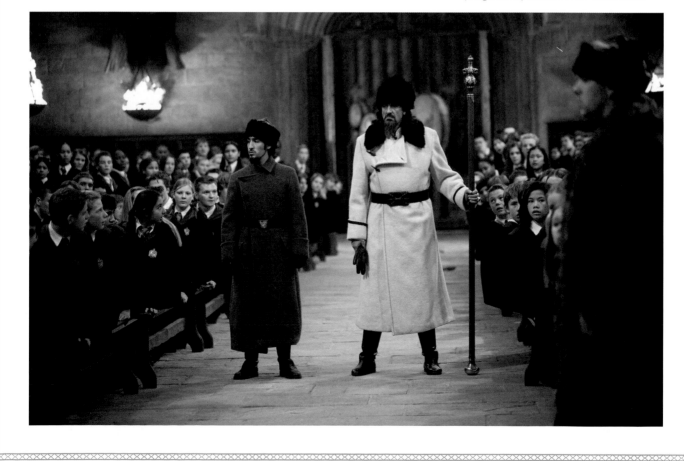

RITA SKEETER

When Jany Temime began to design the outfits that *Daily Prophet* reporter Rita Skeeter would wear during the events of the Triwizard Tournament, she noticed that "gossip journalists always seem to coordinate with the occasion. If they're at Ascot, they wear a hat; if they're at a car race, they wear a leather jacket." Rita Skeeter's attire was designed so that she always matched the story she was reporting, and actress Miranda Richardson agreed with the idea, believing that, "It's as much of a duty to her to look right for the occasion as it is to tell the truth—as she sees it —for her readership." Temime was initially inspired by the Hollywood gossip columnists from the 1940s, who dressed as extravagantly as the stars they interviewed, but a consultation with Richardson encouraged her to explore the "business" side of Skeeter's reporting. Richardson felt that Skeeter thought constantly about increasing not only her sales but her notoriety. "Rita Skeeter wants power," Temime explains. "She has a cruel thirst for it, and Miranda wanted to bring out a touch of madness in her look that displayed this, so we switched to suits."

Skeeter's clear "poison pen" approach to journalism is reflected in the outfit she wears during her first meeting with the school champions; Temime refers to the color as acidic green. "If it was a liquid, it would be poisonous, you'd better not drink it!" The collar and cuffs of what Temime calls one of her favorite outfits are adorned in a bold pink faux fur. The champions' first challenge finds Rita decked out in a high-booted, leather ensemble that recalls

> APPEARANCE: *Harry Potter and the Goblet of Fire*
>
> OCCUPATION: Reporter for the *Daily Prophet*, author of *The Life and Lies of Albus Dumbledore*
>
> ADDITIONAL SKILL SET: Animagus

INSET: Miranda Richardson as Rita Skeeter; BELOW LEFT: Skeeter's outfit for the Triwizard Tournament's first task—dragons—is appropriately reptilian as seen in the film and in original sketches for *Harry Potter and the Goblet of Fire*; OPPOSITE CENTER: Jany Temime's concept for the dress she fabricated in an "acidic green," worn during Skeeter's initial introduction to the champions, Cedric Diggory and Harry Potter; BELOW RIGHT AND OPPOSITE TOP: The journalist's ensembles for the second and third tasks, all sketches by Mauricio Carneiro.

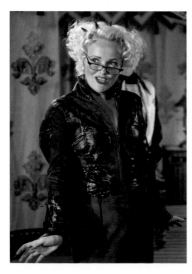

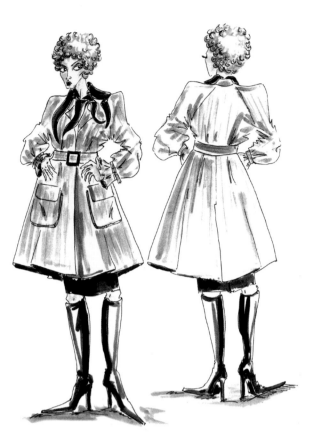

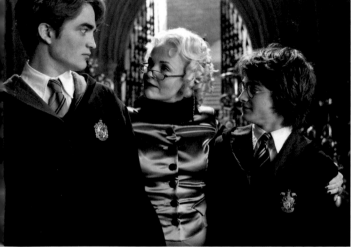

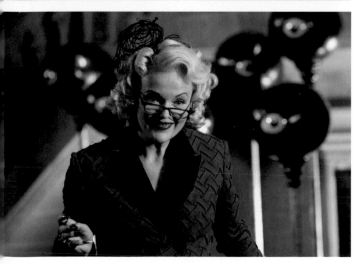

"I'm Rita Skeeter. I write for the 'Daily Prophet' but, of course, you know that, don't you?"

—Rita Skeeter, *Harry Potter and the Goblet of Fire*

the scaly skin of the dragons used in the task. For the second task on the lake, Temime designed a blue and green poncho-like outfit with stylized appliqued aquatic plants, something that she saw as being a staple of Skeeter's wardrobe, as "she might go to an event where there was water involved. She's always prepared." Skeeter's suit for the final task at the maze, is a reddish orange and "quite angular and spiky." In flashbacks, she is seen in a formal pinstriped wizardly gray suit.

Rita Skeeter had to have a "fairly hard makeup," chief makeup artist Amanda Knight explains. "It wasn't to be a soft, alluring look, but Miranda was really game for whatever we planned for her and came in with some ideas of her own." Richardson endured the character's long nails, but drew the line at Skeeter's gold teeth, mentioned in the novel. Miranda Richardson and director Mike Newell opted instead for dentures embedded with a diamond.

It took three tries to get the right hair color for the character. "We tried brown, we tried red, we tried really dark," says makeup artist Eithne Fennel. "Then we just realized it had to be blonde." Fennel agreed that Skeeter's hairstyles, just like her outfits, would be dictated by the event. "In general, we wanted her basic look to be like her hair had just come out of rollers. But with the dragons, we put a headband on her with horns in it. By the lakeside, her hair flowed a little more. So each time you saw her, she had a different hairdo." Richardson was pleased with the overall look of the character. "Rita has a wonderful old-fashioned glamour," she says, "and she certainly won't go missing in a room!"

Copyright © 2020 Warner Bros. Entertainment Inc. HARRY POTTER characters, names and related indicia are © & ™ Warner Bros. Entertainment Inc. WB SHIELD: ™ & © WBEI. WIZARDING WORLD trademark and logo © & ™ Warner Bros. Entertainment Inc. Publishing Rights © JKR. (s20)

INSIGHT EDITIONS

PO Box 3088
San Rafael, CA 94912
www.insighteditions.com

Find us on Facebook: www.facebook.com/InsightEditions
Follow us on Twitter: @insighteditions

All rights reserved. Published by Insight Editions, San Rafael, California, in 2020. No part of this book may be reproduced in any form without written permission from the publisher.

Library of Congress Cataloging-in-Publication Data available.

ISBN: 978-1-68383-831-9

Publisher: Raoul Goff
President: Kate Jerome
Associate Publisher: Vanessa Lopez
Creative Director: Chrissy Kwasnik
Designer: Megan Sinead Harris
Editor: Greg Solano
Managing Editor: Lauren LePera
Senior Production Editor: Rachel Anderson
Senior Production Manager: Greg Steffen

Written by Jody Revenson

Insight Editions, in association with Roots of Peace, will plant two trees for each tree used in the manufacturing of this book. Roots of Peace is an internationally renowned humanitarian organization dedicated to eradicating land mines worldwide and converting war-torn lands into productive farms and wildlife habitats. Roots of Peace will plant two million fruit and nut trees in Afghanistan and provide farmers there with the skills and support necessary for sustainable land use.

Manufactured in China by Insight Editions

10 9 8 7 6 5 4 3 2 1

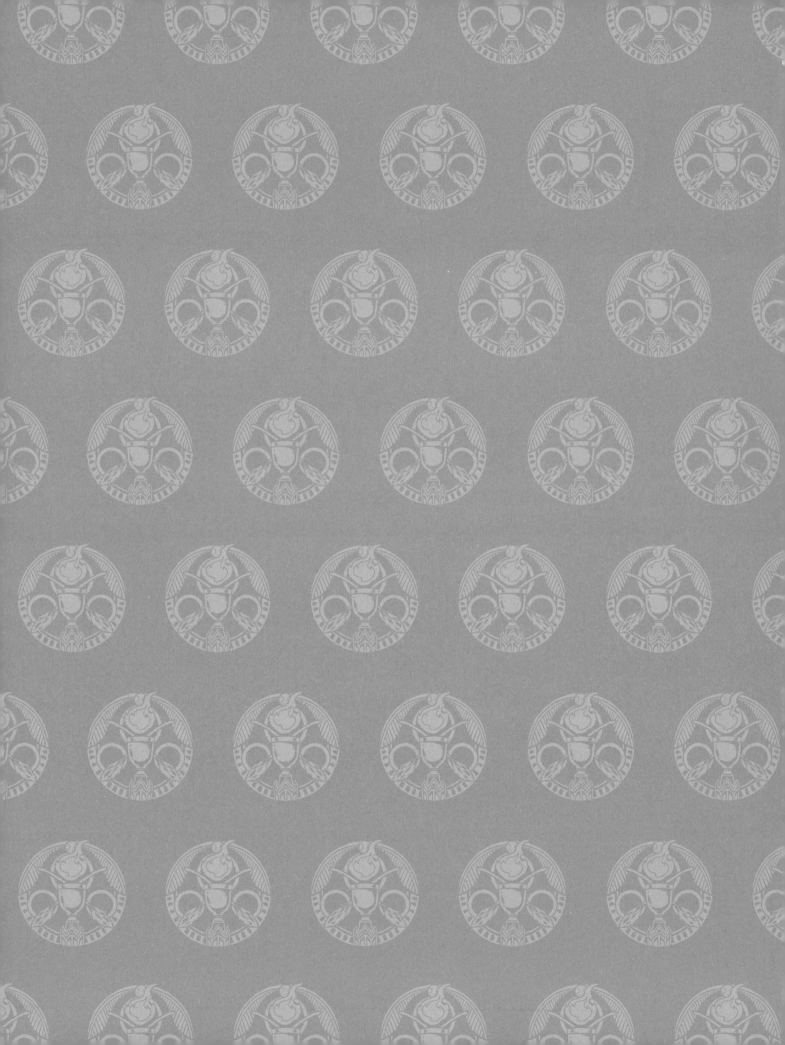